RY RENÉ BURRI HENR~ ~ARTIER-
~D DEPARDON THOMAS ~~~AK
~NE FRANCK STUART ~R~N~~IN
~ GLINN PHILIP JONES GRIFFITHS
~RVEY BOB HENRIQUES THOMAS
~ KALVAR CARL DE KEYZER KENT
~ LADEFOGED SERGIO LARRAIN
~UL LOWE STEVE MCCURRY ALEX
~EISELAS WAYNE MILLER JAMES
~UI PINKHASSOV ELI REED MARC
~DO SCIANNA DAVID SEYMOUR
~TEELE-PERKINS LARRY TOWELL
~N WYLIE PATRICK ZACHMANN

* US edition Magnum Soccer

MAGNUM**FOOTBALL***

Introduction by Simon Kuper

I N MORE THAN 50 years of Magnum's life, its photographers have almost never set out to photograph football. Yet when the agency searched its archive for this book, it unearthed 4,000 pictures of the game, taken over the years by Magnum photographers ostensibly trying to shoot a monsoon, or Islam, or political protests in Albania, or even dogs. Some pictures had never been used before, some never even edited.

The range is as wide as Magnum's: whether you were the oil worker in the United Arab Emirates playing in a bra (p.33), or the El Salvadorean keeper swinging from the crossbar (p.157), or the two boys captured in a shaft of light on a cobblestoned square by Henri Cartier-Bresson one forgotten day in 1959 (p.108), you are in this book.

These pictures may at first sight appear to be a hobby pursued by Magnum photographers besides their real work. Abbas, born in Iran, living in France, is known for his work on Islam and Christianity but is also a soccer fan; the Frenchman Guy Le Querrec, famous for his jazz photographs, loves the game too. Both have the habit of returning from unrelated shoots with the odd football picture. There are others like them at Magnum: the agency's annual general meeting, the only time all the photographers get together, is held in summer and often clashes with big football competitions. In July 2000, when the meeting dragged on into the evening, there was a small exodus to watch France-Italy in the European Championship final in a London pub.

It is natural to assume that football is just a hobby for Magnum. When you think of the agency you think of the great events: wars, Robert Capa stepping on the land-mine, and the lone Chinese student with the shopping bag defying the tanks in Tiananmen Square. But football is an essential Magnum theme (and I am not just saying that because I am writing the introduction to a book of Magnum's football photographs).

The men who founded the agency in the penthouse restaurant at the Museum of Modern Art in New York in April 1947 – the Hungarian Capa, the Pole 'Chim' Seymour and the Parisian Cartier-Bresson (the Englishman George Rodger was absent) – had been formed by World War Two. Revulsed at the carnage and hatred, they had in mind a better world based on international brotherhood. It was the spirit of the age: the United Nations was founded a year after Magnum. 'People are people the world over', was the title of Magnum's first joint project, a year-long essay for *Ladies' Home Journal*, and in 1955 the agency contributed many of the pictures in the 'Family of Man' exhibition at the Museum of Modern Art, considered the most influential photography exhibit ever.

Well, one of the Family of Man's great universal experiences is football. People the world over do it. It is a universal human urge (even if in most places and times it can seem, wrongly, to be just a male one). When people are playing football, where they come from and who they are ceases to matter. (The same is true, more or less, when you work for Magnum. The photographers come from everywhere and the only qualification

is quality.) For the duration of the game, race and creed and status vanish: there is no difference between a prisoner and a monk, a Frenchman and a Sudanese. Because everyone in this book is playing the same game, the differences in their surroundings are made apparent and yet, simultaneously, rendered irrelevant. As long as the match lasts, worldly hierarchies cease to operate. Even Pelé momentarily becomes just another spectator in a rapt, gesticulating crowd (p.84).

The game is the same whether you are playing in the mud of Maharashtra, the Tuileries Gardens in Paris or a refugee camp. If the man scoring in the little goal in Khartoum in 1972 (p.142) – or does he hit the post? – were transported to the match in the caged oil platform in the Atlantic Ocean off Brazil in 1998 (p.52), he would be able to join in instantly. The style of play may vary slightly (the long-ball game would probably not work well in the middle of the ocean, for instance) but a good goalscorer scores anywhere. Football is always the same essential scene. Magnum's photographers have merely rendered it in many styles and places and eras.

Of course the conditions depicted in these photographs matter, but at the moment when the picture is taken they matter to the photographer and the viewer rather than to the players. We are used to seeing football played on perfect grass by players in matching kits. This book reminds us that the game is usually played in adverse conditions, in the mud or uphill. This is the universal experience, not playing in the

Nou Camp. But for as long as the game lasts, the footballers are elevated above their surroundings. The boy taking a penalty in Florida (p.146) may know that a bush fire is filling the sky behind him but he does not seem to care. Similarly, his peers kick around an undersized ball in the ruins of Nagornyy-Karabakh (p.106) just after the Armenian earthquake, and the keeper swinging from the Salvadorean crossbar seems oblivious to the soldier toting a machine gun behind him. Football is football, whether by the Berlin Wall or in war-torn Sarajevo. These photographs tell a paradoxical truth: people are people the world over, they just live in different conditions.

At the same time, by depicting a human pursuit that is almost universal, the photographs make the difference in surroundings more acute. Look at a picture of children starving in a refugee camp and it is possible to detach oneself: they hardly seem to belong to the same species as we do. But children kicking a ball around a refugee camp clearly do. However exotic the scene, football renders it instantly familiar.

There is another sense in which these photographs sit in the Magnum tradition. Cartier-Bresson, now in his nineties, once famously wrote that every great picture captures 'the decisive moment'. Perhaps the best expression of the concept is Capa's well-known photograph of a rifleman flinging out his arms as he is shot during the Spanish Civil War. Capturing the moment is the Magnum ethos. It is done by working (often with a little Leica) in the flux of life, not in the studio. In no photographic genre

is life in greater flux than in sport: snap a moment late and you are too late. 'To take photographs', Cartier-Bresson said, 'is to hold one's breath, when all the faculties converge in the face of fleeting reality.' Reality is particularly fleeting in football, a game in which the photographer never knows when the decisive moment will arrive. In Madrid in 1933, in front of a great blank wall with asymmetrical windows, Cartier-Bresson caught the boy goalkeeper palming a shot away in the only instant in which he ever did it (p.148).

In some settings a photographer can cheat, pretending to spontaneity where none exists. It has been suggested that Capa's rifleman was posing. But in football certain moments are impossible to stage. A year after that Madrid photograph, Italy played Czechoslovakia in the World Cup final in Rome. Eighty minutes into the game, with Italy losing 1-0, an Argentine-turned-Italian forward named Raimondo Orsi raced through the Czech defence, feigned to shoot with his left, and struck a brilliant equalizer with his right. Italy went on to win the match. The next day Orsi tried to recreate his strike for the benefit of the press photographers, without the hindrance of a goalkeeper; after twenty failed attempts he gave up.

Much of photography is geometry, the revelation of unexpected shapes and angles. Football provides endless examples: Harry Gruyaert's triangle of boys in the scrub-grass of the Catholic mission at Kometou in Cameroon (p.130); the symmetry of goalposts; and

players' arms and legs balletically extended in search of balance while running, jumping and kicking. A photographer is like a playmaker in football, a 'number ten', who sees angles nobody else does: a gift that connects Abbas, Le Querrec or Cartier-Bresson with another great Frenchman, Zinedine Zidane.

Yet another reason why football is made for photographers is that it offers the human body in motion. A perfect example is Cartier-Bresson's 1969 picture of Parisian boys sprinting with a ball through the Tuileries, past a neo-classical monument on which a bare-chested muscular figure waves a flag (p.177). The slim, bare-legged boy, running so fast he begins to blur, has as much grace as the statue.

Playing football, hundreds of millions of people seem able to achieve grace. There is hardly a professional footballer in this book (unless some of the children captured in Peru or Paris or Gabon later made it big), yet on the ball these anonymous people achieve an elegance they probably possessed in no other setting. The fat, bald middle-aged man leaping into a header in a London park (p.123), David Seymour's invalid children playing in Rome in 1948 – one with two false legs and a crutch (p.39) – Bruno Barbey's man in overalls leaping to catch a shot in front of the goods entrance (p.151) – all in that decisive moment could be Greek statues themselves.

Some of the subjects in these photographs are poor or mutilated, but that is not their identity. That is incidental. Here they are footballers. The boy virtually doing the splits in

a Naples street in 1959, the ball under the sole of his boot, before an audience of a few half-interested toddlers (p.109), could be Johan Cruyff or Rudolph Nureyev. Even the gorgeous, forgotten actress Corinne Piccoli may have been at her most lissome at the moment in 1967 when Raymond Depardon caught her swerving past an opponent, looking as if she were about to laugh or cry (p.116).

If the subjects could see these pictures (and maybe some of them can; maybe you are in this book), I suspect most would be delighted. This is how they would want to be remembered. Take David Alan Harvey's picture of the little boy in a tight T-shirt balancing a toy ball on his head in the Honduran capital Tegucigalpa in 1990, watched by a little girl leaning against a lamppost (p.180). It must have been a good moment (for the boy at least), perhaps as good as it gets.

The look on the faces of the people in these photographs tends to be rapt. The players are lost in football, and rarely seem aware that they are being snapped, even if, like James Nachtwey's Brazilian naturists, they have no clothes on (p.18). Almost no one has prepared for the picture. Marilyn Monroe, tongue out of her mouth as she girds herself to execute a ceremonial kick-off in New York in 1959 (p.88), and the even more delectable Piccoli are among the only ones who do mug for the camera. The rest are childlike in their unselfconsciousness, like the man in underpants nudging a ball beside the Ganges river (p.55), or the boy in Grenada who appears to be playing 'keepy-up' as an American tank

rolls past invading his country (p.114). If he is unaware of the tank, he certainly hasn't noticed the photographer. Even the boys in Madrid staring into Cartier-Bresson's lens are not posing, just wondering what that man is doing there.

During matches, the spectators are also too rapt to notice the lens. The two boys in their pointy hats watching Queens Park Rangers in London in 1983 do not care that they look like elves (p.167), and perhaps the finest study in unselfconsciousness is David Hurn's in Cardiff in 1977: a boy stands on a chair so he can see the pitch over the heads of the crowd; his father watches with his arm around the boy; and an old man by the father's side (the grandfather?) yells something towards the field (p.80). They probably never knew they were being photographed. Many fans in this book even have their back to the lens, like the line of shaven-headed Cambodian monks gripped by the game (p.81). Usually, there is no interaction between photographer and subject.

Only before and after the match do fans pose for the camera. Then they look straight into the lens like the French fans with the tricolour painted on their faces celebrating victory in the World Cup in 1998 (p.75), or the Manchester United fan covered in badges (p.85).

A great oddity of modern football is that the spectators are just as much performers as the players. People dress up and paint themselves and wear silly things on their heads as if at a medieval carnival. The three curvaceous Jamaican women, dressed in almost

nothing, inspiring their team to a 5-0 defeat against Argentina at the World Cup of 1998, not only provided a better spectacle than their players: the one with the protruding nipple also became more famous (p.170).

The most self-aware supporters of all are the young Japanese. They seem to have seen pictures of all the other fans, and to have memorized them. The youth wearing a team shirt, Burberry scarf, sunglasses and a felt hat, cheering into Martin Parr's lens amid confetti, is as aware of the camera as a model on the catwalk (p.179). But this sort of conscious performance is the exception in this collection.

An agency whose work portrays the Family of Man in one guise or other was always going to have a great horde of football photographs. Herbert List's picture taken in Albania, in which the only features are a set of goalposts and a solitary figure in the middle distance, sums it up: Planet Earth as a football field (p.152). You may barely recognize a player in this book, but these pictures capture everybody's experience of football, the way we have all played the game, and the sorts of places where we played it. Through the sport, the photographs capture the world and reveal an unseen face of Magnum.

THE TEAM

'In a football match everything is complicated by the presence of the opposite team'

Jean-Paul Sartre

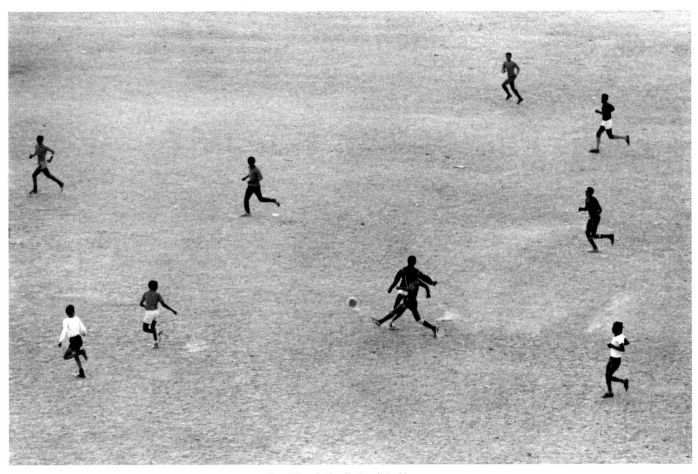

Marc Riboud, Riyadh, Saudi Arabia, 1974

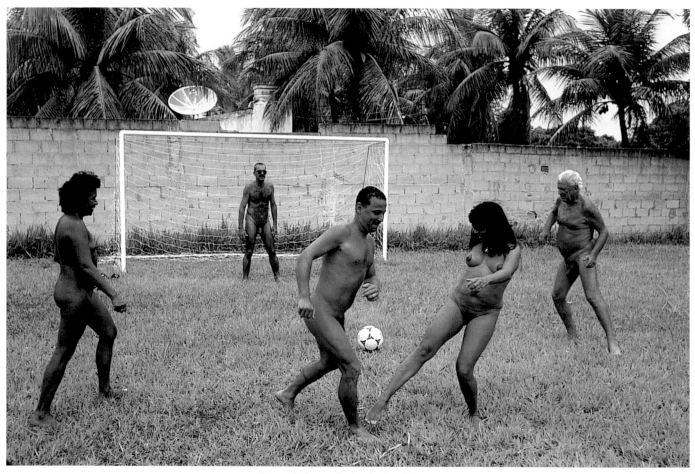

James Nachtwey, Guaratuba, Brazil, 1998

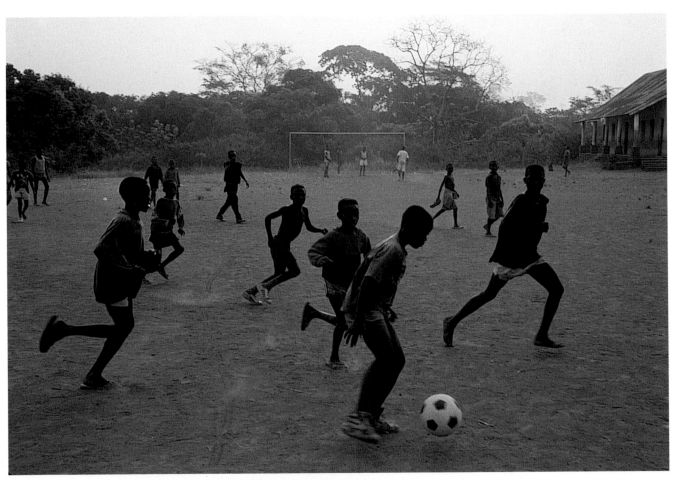

Harry Gruyaert, Catholic mission, Kometou, Cameroon, 1998

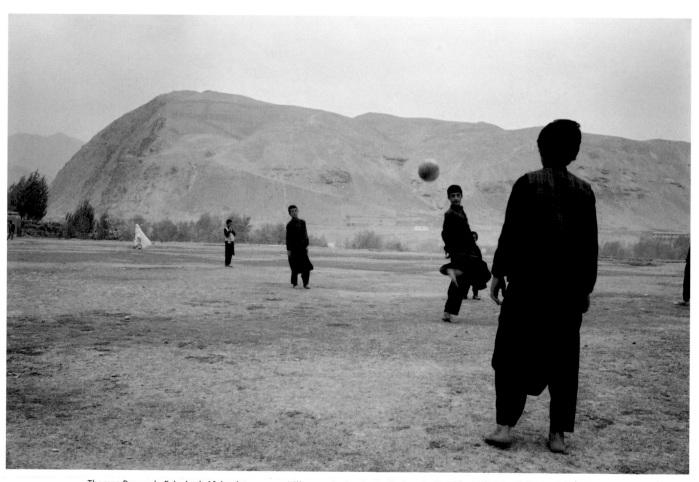

Thomas Dworzak, Faizabad, Afghanistan, 2001. Villagers playing football after the Northern Alliance victory over the Taliban

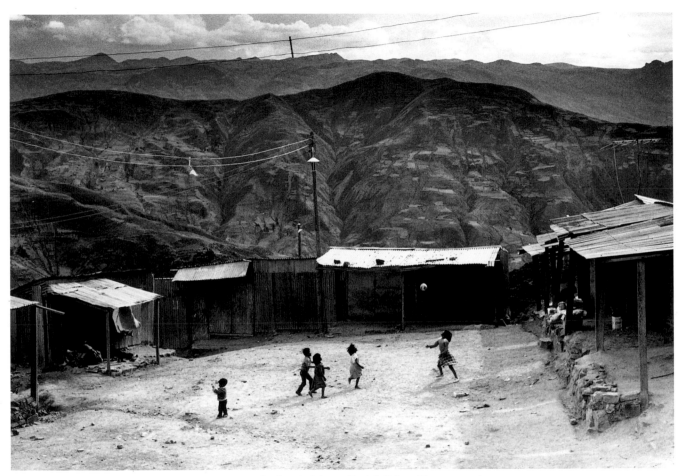

Ferdinando Scianna, Kami, Bolivia, 1988

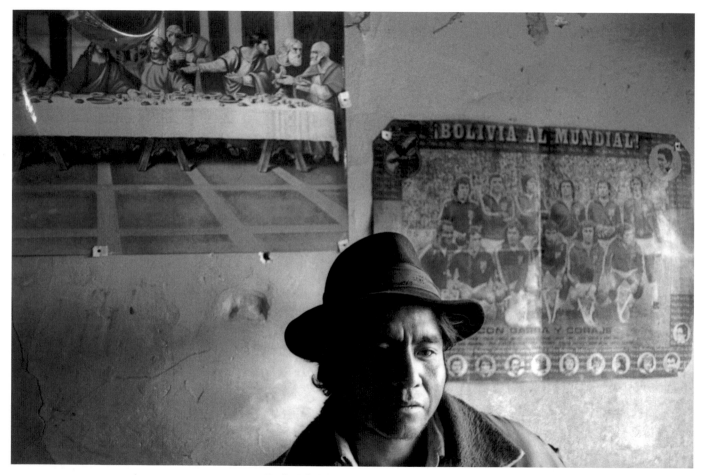

Ferdinando Scianna, Kami, Bolivia, 1986

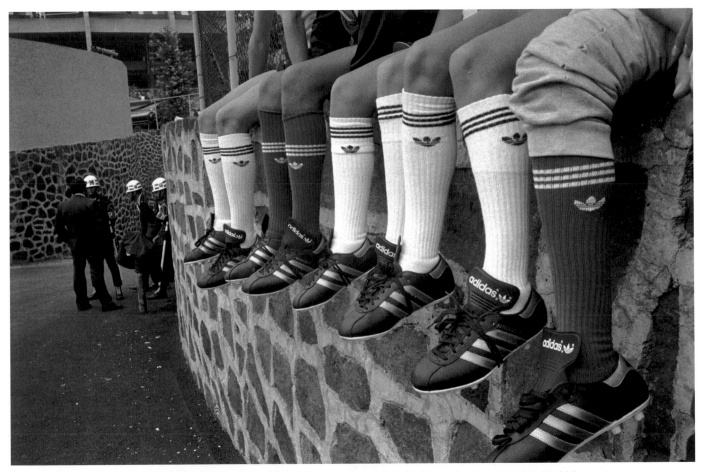

John Vink, Azteca Stadium, Mexico City, Mexico, 1986. Preparations for the opening ceremony of the World Cup

Martin Parr, Benidorm, Spain, 1997

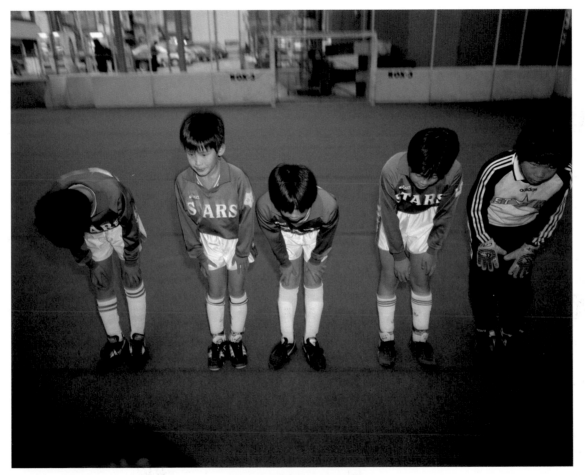

Martin Parr, Tokyo, Japan, 1998

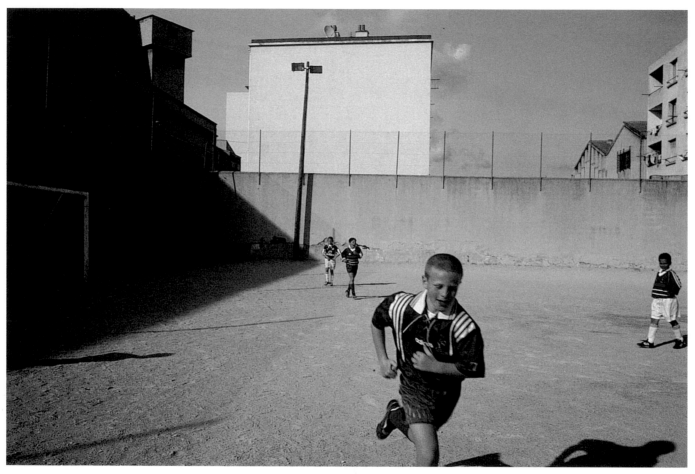

Lise Sarfati, Marseilles, France, 1998

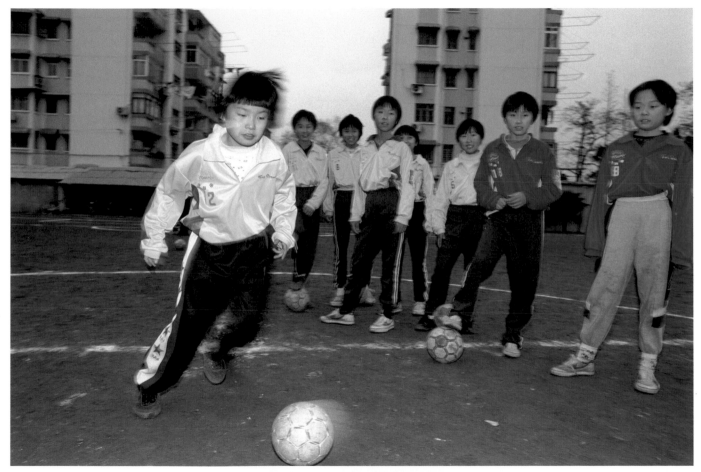

Patrick Zachmann, Shanghai, China, 1997

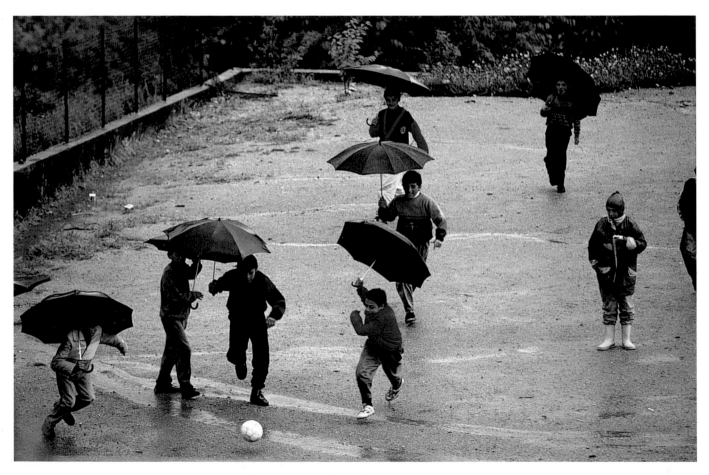

Thomas Hoepker, Trás os Montes, Portugal, 1992

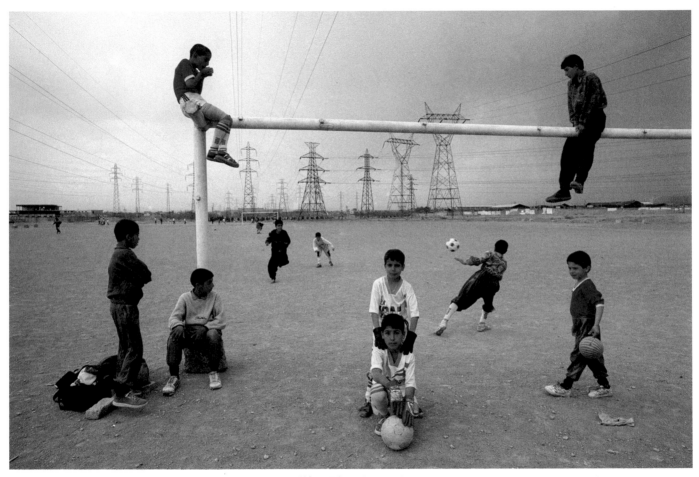

Abbas, Tehran, Iran, 1998

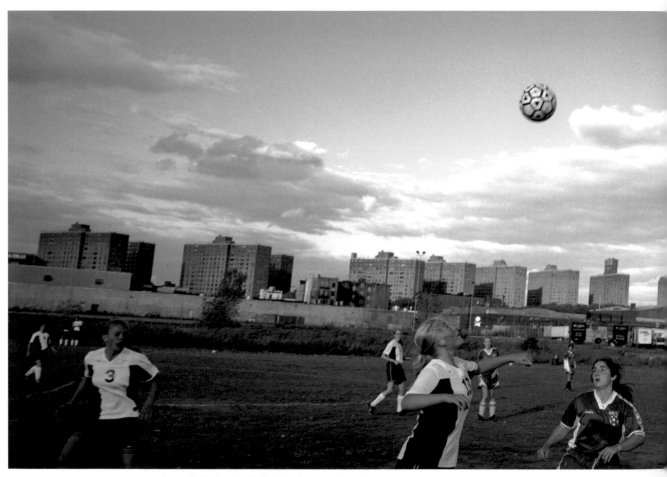

Susan Meiselas, Randall's Island, New York, USA, 2001

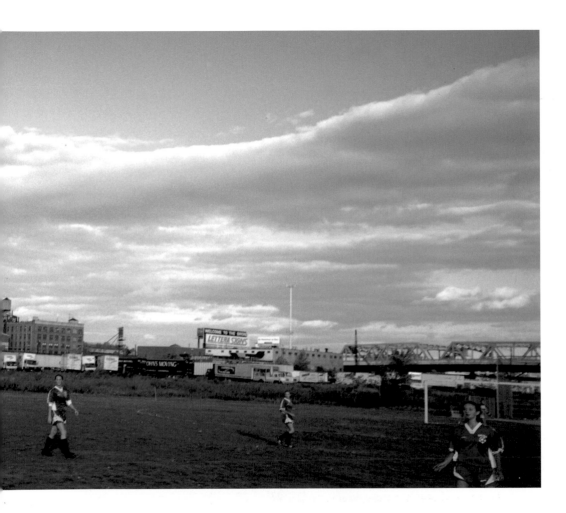

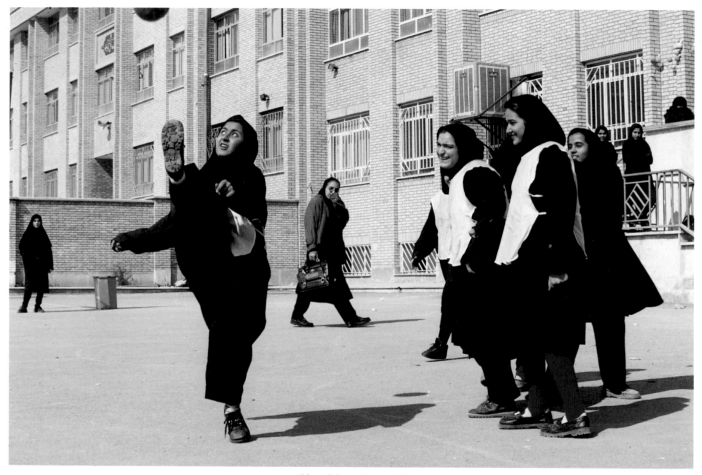

Abbas, Tehran, Iran, 1998

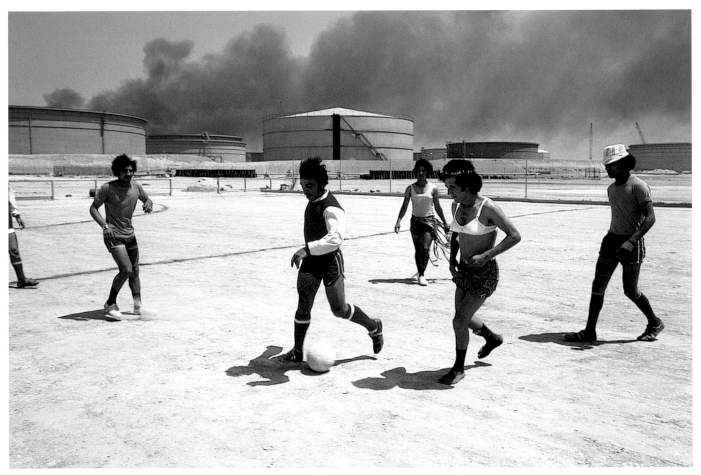

René Burri, Das Island, United Arab Emirates, 1976

Wayne Miller, Newport, Rhode Island, USA, 1964
Morning training for the crew of the racing yacht *Sovereign*.
They were preparing to take part in the Americas Cup Trials

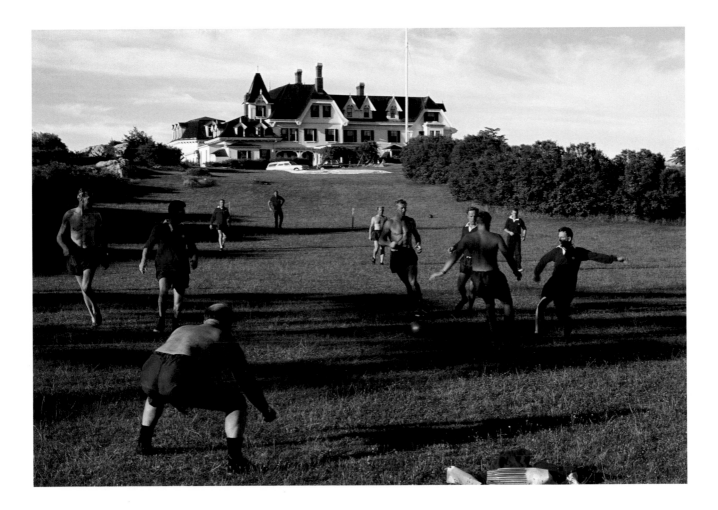

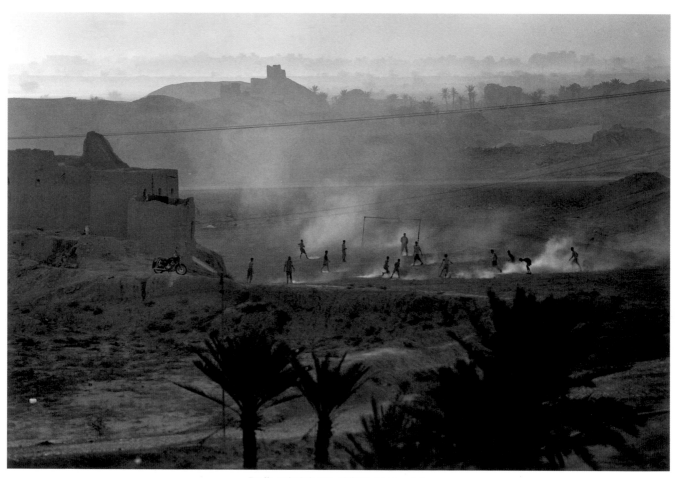

Ferdinando Scianna, Shibam, Yemen, 1999

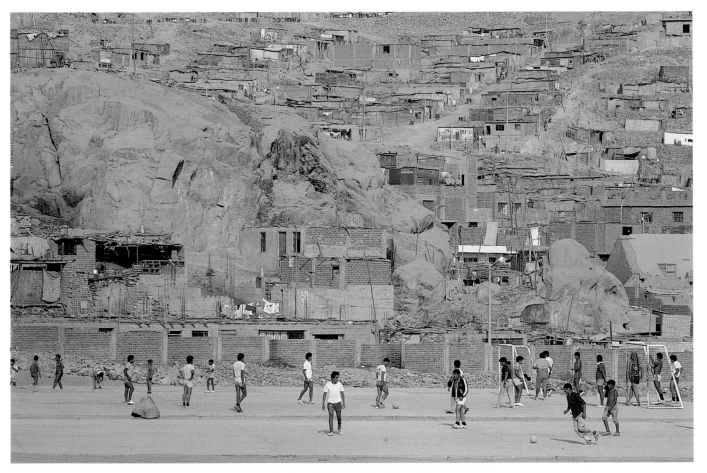

Ferdinando Scianna, Lima, Peru, 1986

David Seymour, Rome, Italy, 1948
A game at the Villa Savoia, a home for crippled children,
maimed during the war or by accidents, often playing with war surplus ammunition

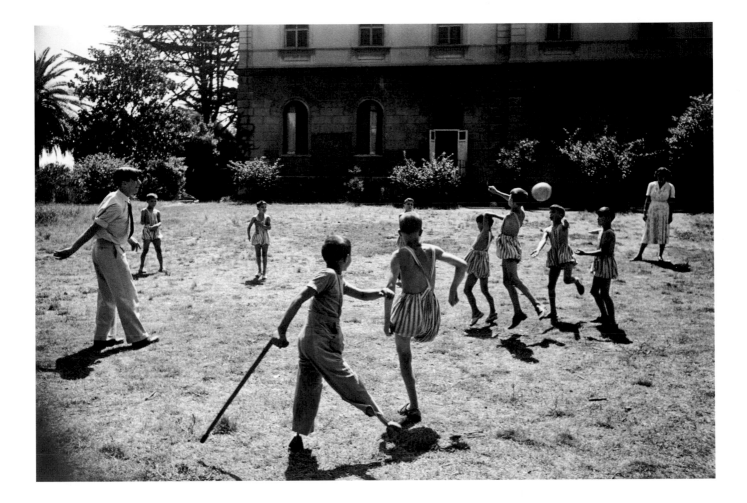

THE PLACE

Then strip lads and to it, though sharp be the weather
And if, by mischance, you should happen to fall,
There are worse things in life than a tumble in the heather,
And life is itself but a game of football.

Sir Walter Scott

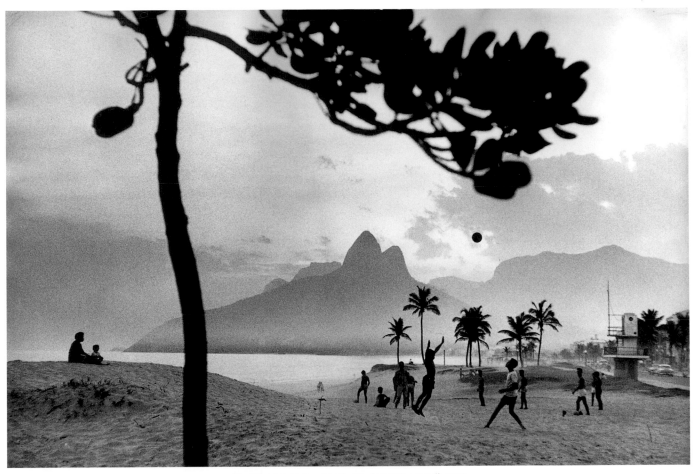

René Burri, Ipanema Beach, Rio de Janeiro, Brazil, 1958

Richard Kalvar, Asnières, France, 1972

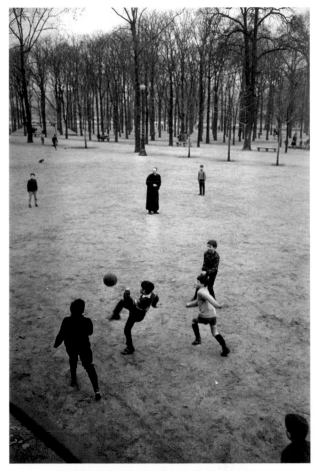

René Burri, Tuileries Gardens, Paris, France, 1967

Burt Glinn, East Rutherford, New Jersey, USA, 1978
New York Cosmos score the winning goal against the Tampa Bay Rowdies at the Giants Stadium.
They won 3-1 to clinch victory in the National American Soccer League

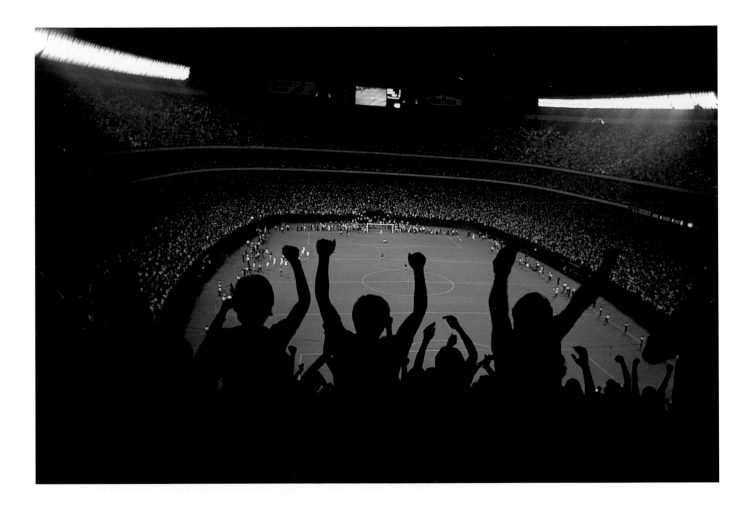

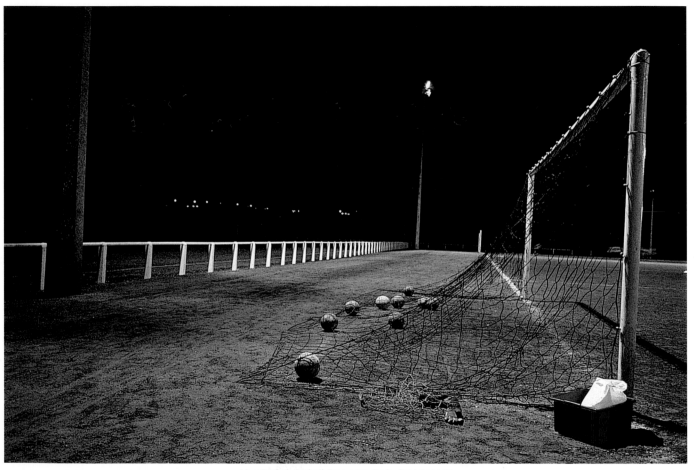

Lise Sarfati, Corbeil-Essonnes, Paris, France, 1997

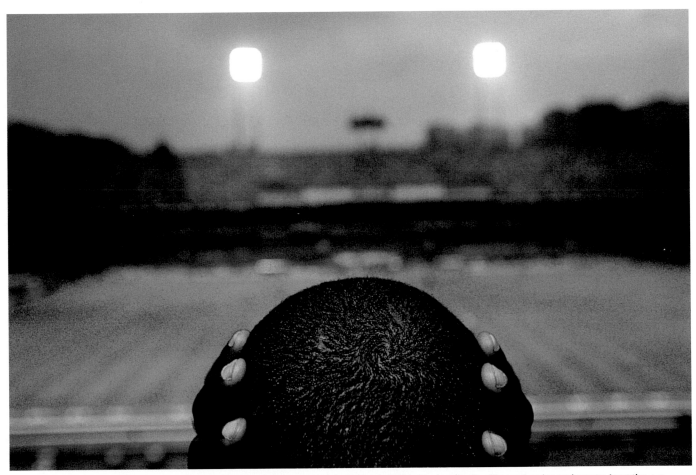

James Nachtwey, Maracana Stadium, Rio de Janeiro, Brazil, 1998. A dejected fan holds his head as the Brazilian national team loses to Argentina 1-0

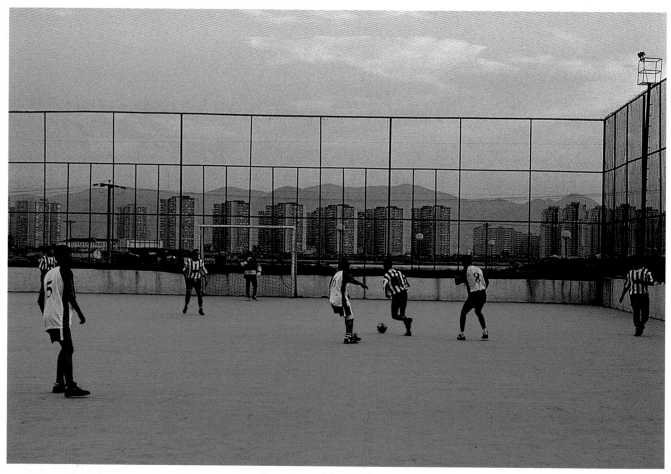

Harry Gruyaert, Izmir, Turkey, 1998

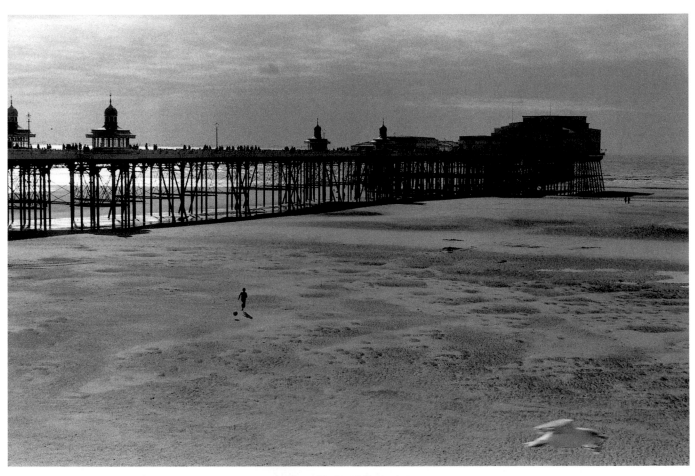

Ian Berry, Blackpool, England, 1975

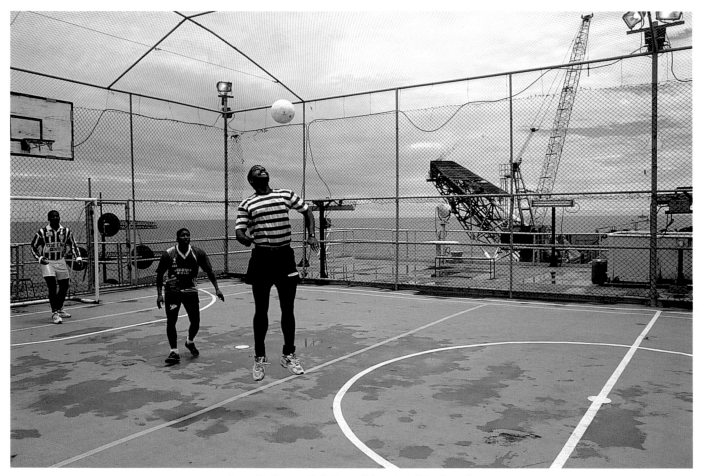

James Nachtwey, oil platform off the coast of Brazil, 1998

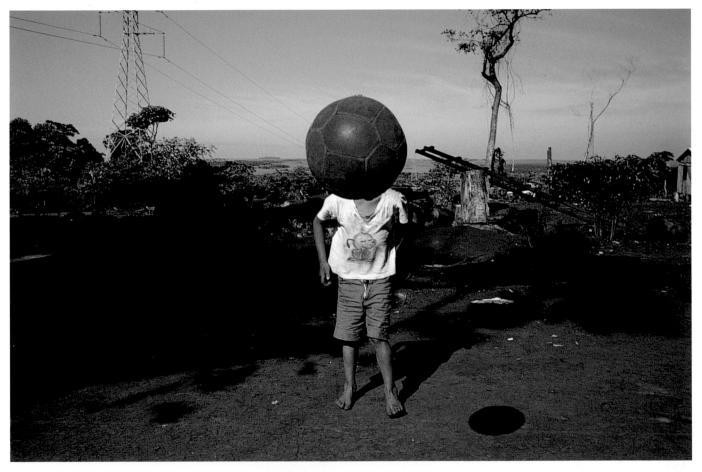

Alex Webb, near Cedrales, Paraguay, 1992

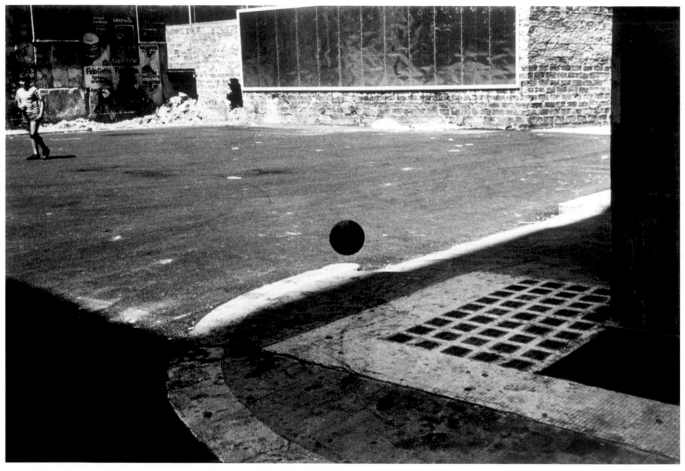

Josef Koudelka, Palermo, Sicily, 1980

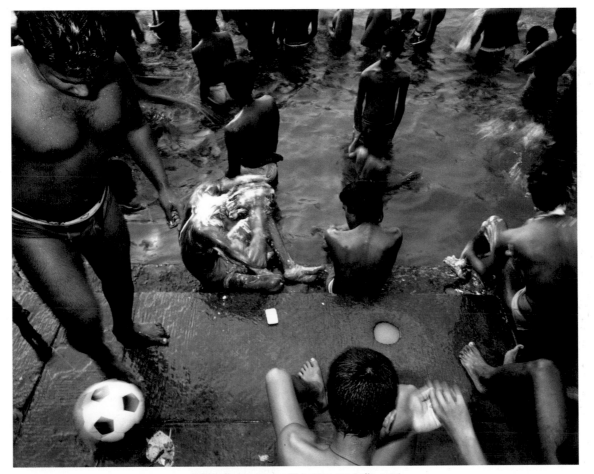

Carl de Keyzer, Ganges River, Benares, India, 1986

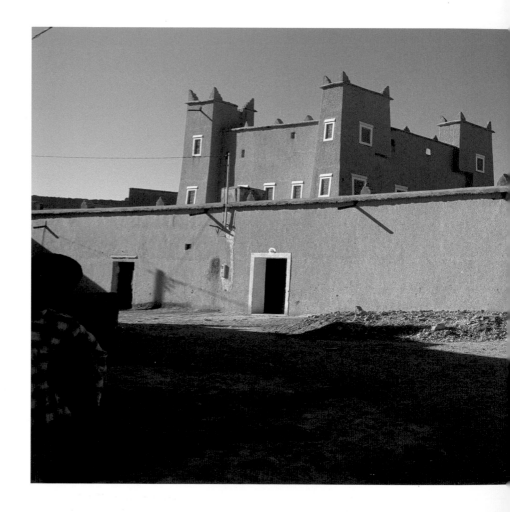

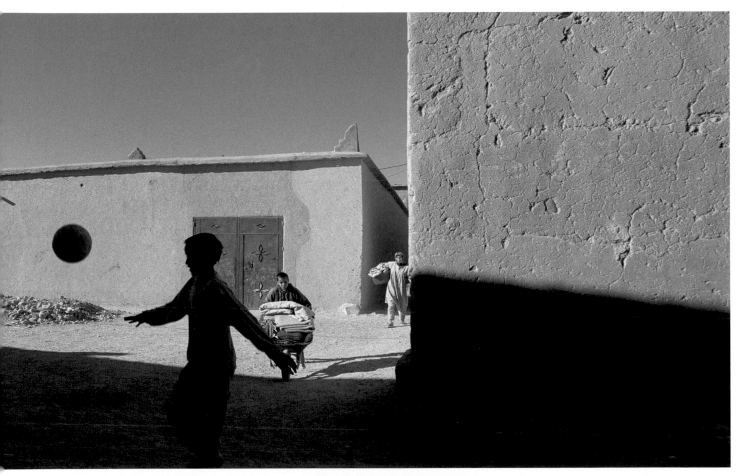

Bruno Barbey, Nkob, Morocco, 2000

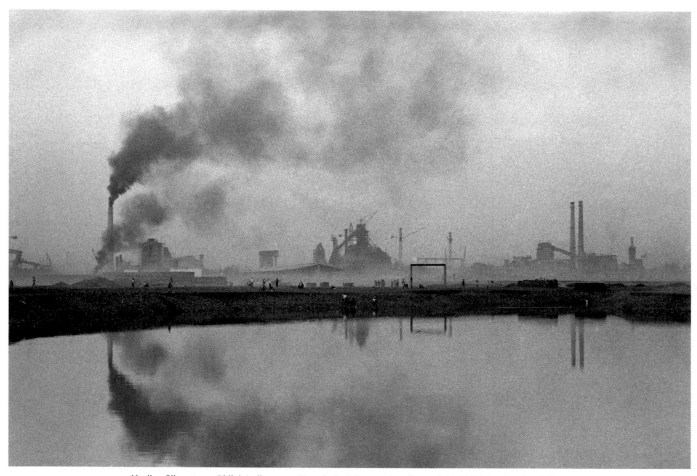

Marilyn Silverstone, Bhilai, India, 1959. Maroda Tank Reservoir in front of the Bhilai Russian Steel Plant

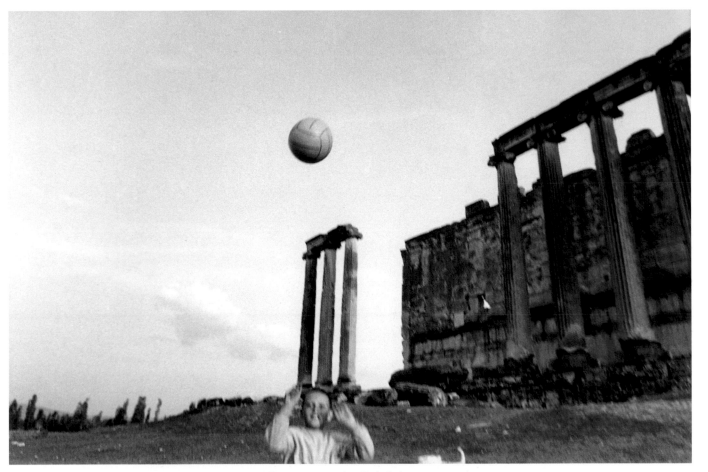

Nikos Economopoulos, Uşak, Turkey, 1990

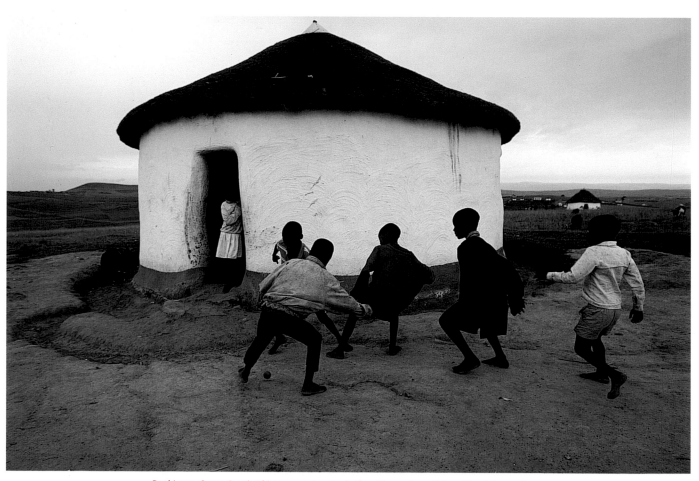

Paul Lowe, Qunu, South Africa, 1994. A game in the village where Nelson Mandela was born

David Alan Harvey, Atacama Desert, Chile, 1987

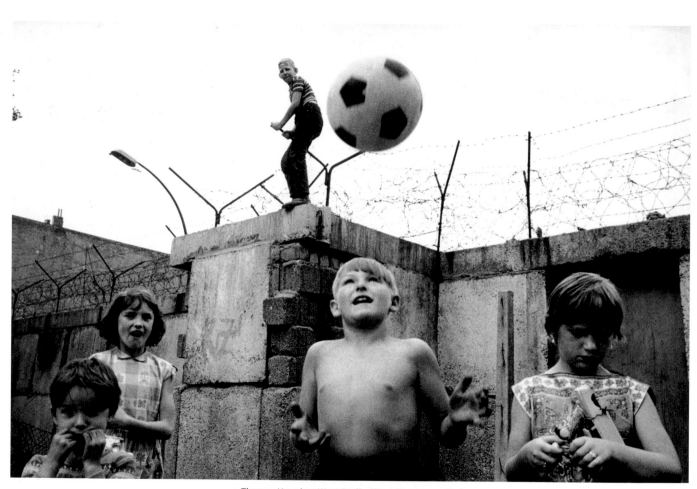

Thomas Hoepker, West Berlin, West Germany, 1963

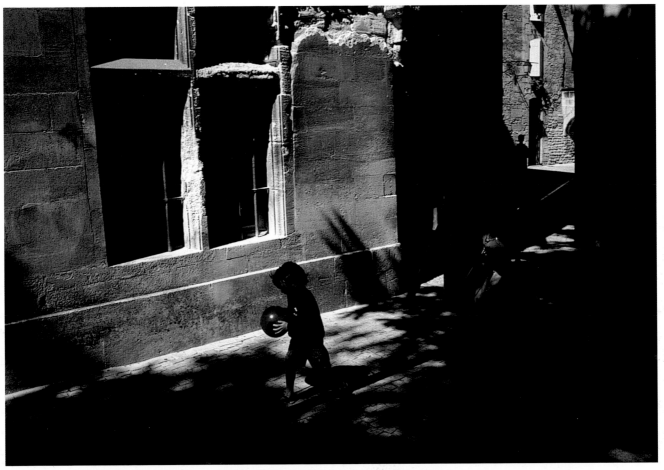

Gueorgui Pinkhassov, Bouches-du-Rhône, France, 1992

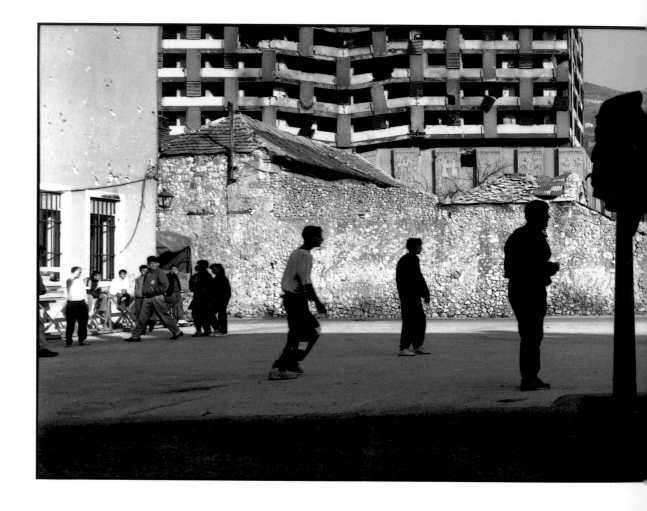

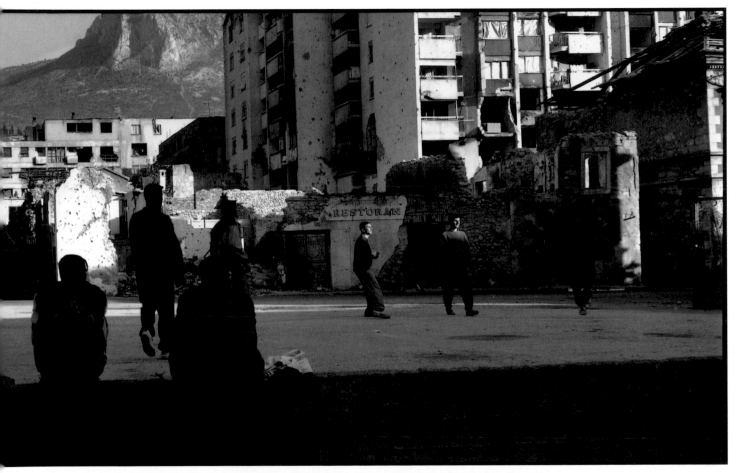

Josef Koudelka, Mostar, Bosnia, 1994. A match in the destroyed Muslim quarter

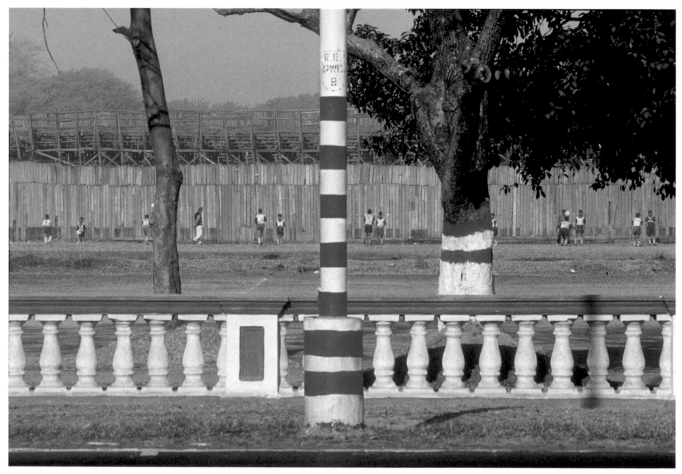

Harry Gruyaert, Maiden Gardens, Calcutta, India, 2001

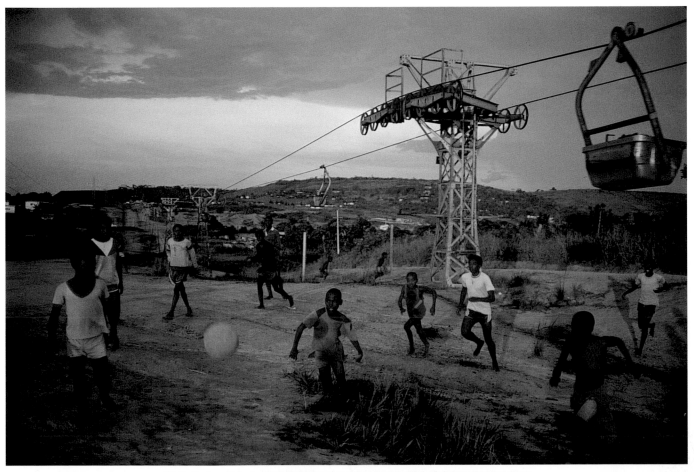

Bruno Barbey, Gabon, 1984. Children playing by a manganese mining transport system

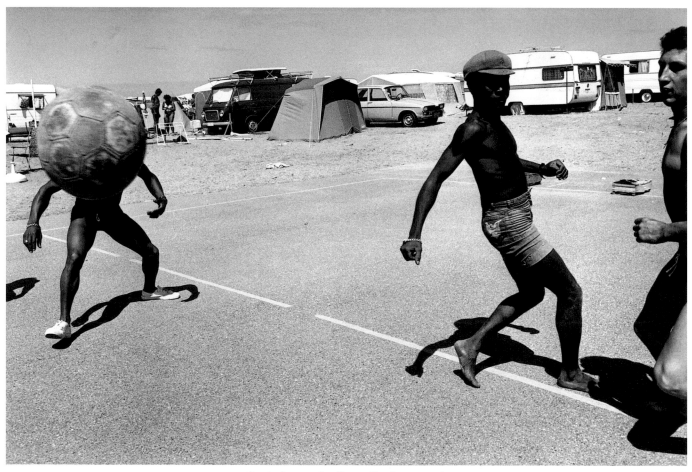

Guy Le Querrec, Argelès-sur-Mer, France, 1976

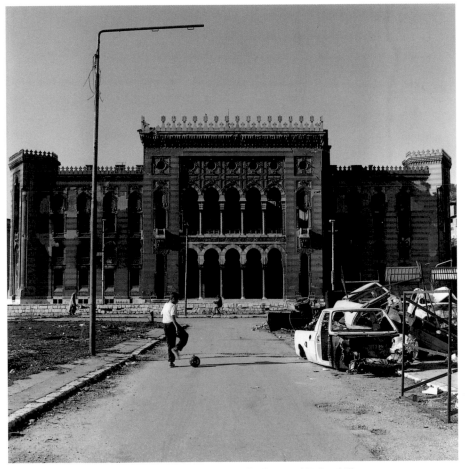

Paul Lowe, Sarajevo, Bosnia, 1994. The destroyed National Library

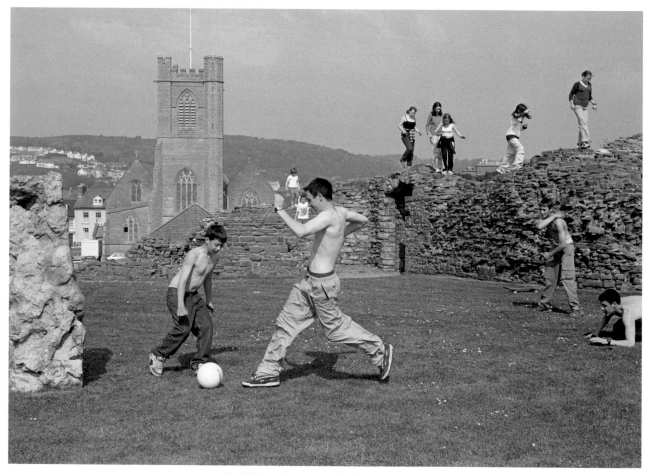

David Hurn, Aberystwyth Castle, Wales, 2000

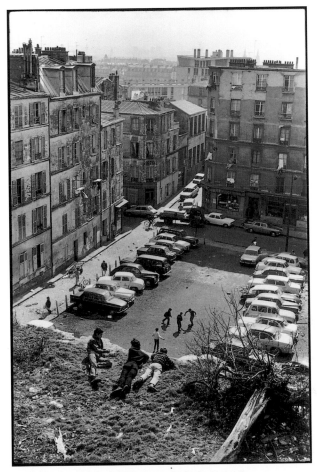

Henri Cartier-Bresson, Paris, France, 1969

THE SUPPORTERS

'There is nothing beyond the touchline'

Jacques Derrida

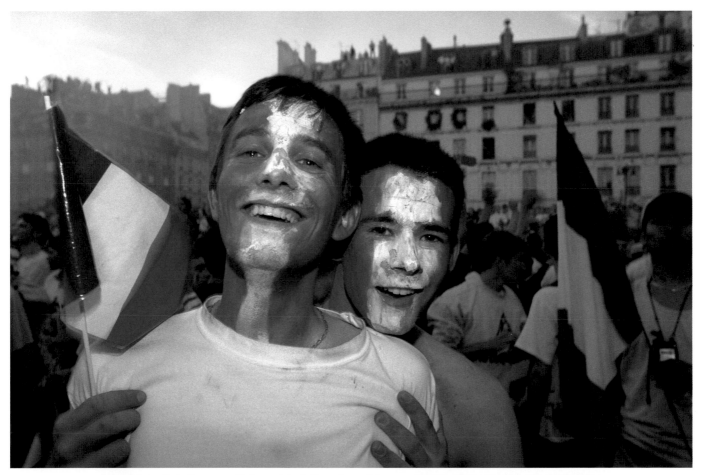

Luc Delahaye, Paris, France, 1998. Fans celebrate France's 3-0 victory over Brazil to win the World Cup for the first time

Chris Steele-Perkins, Newcastle-upon-Tyne, England, 1996
Newcastle United supporters following a 1-1 draw with Tottenham Hotspur in the final game of the season.
Newcastle were beaten to the Premiership league title by Manchester United having led for much of the year

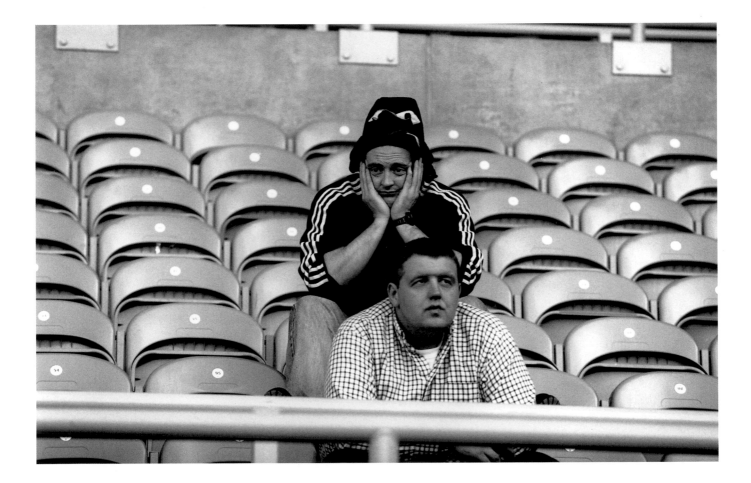

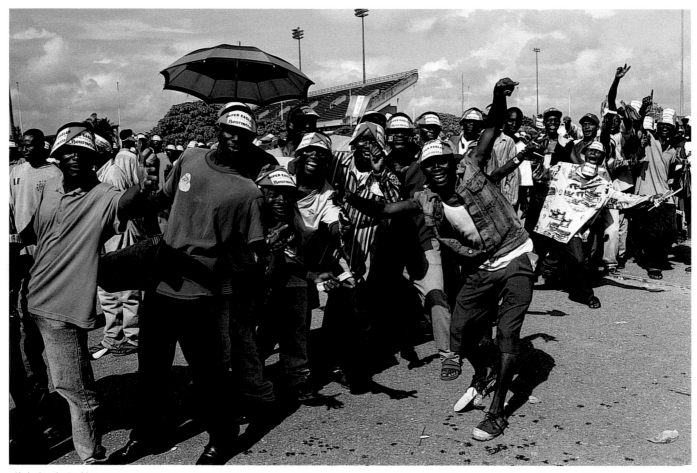

Chris Steele-Perkins, Lagos, Nigeria, 1997. Supporters of the Nigerian team before the World Cup qualifying match between Nigeria and Kenya. Nigeria won 3-0

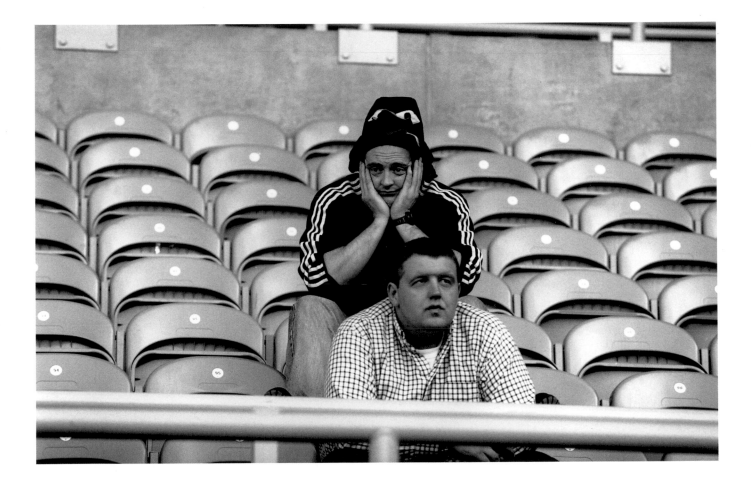

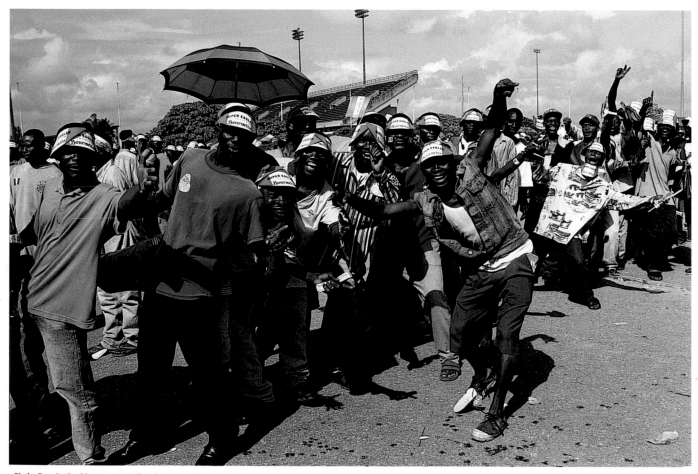

Chris Steele-Perkins, Lagos, Nigeria, 1997. Supporters of the Nigerian team before the World Cup qualifying match between Nigeria and Kenya. Nigeria won 3-0

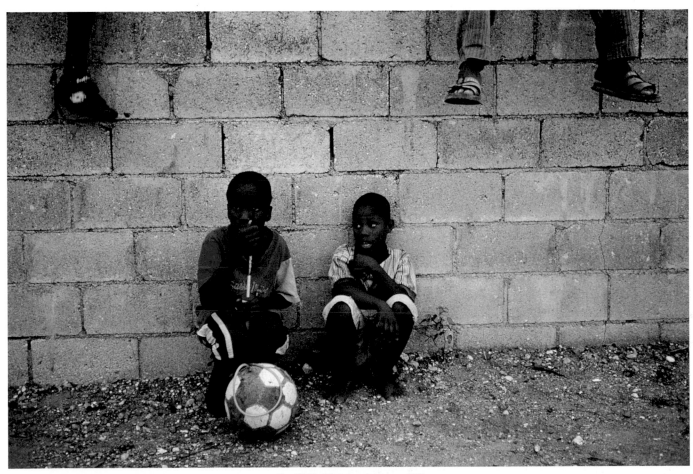

Alex Webb, Kingston, Jamaica, 1988

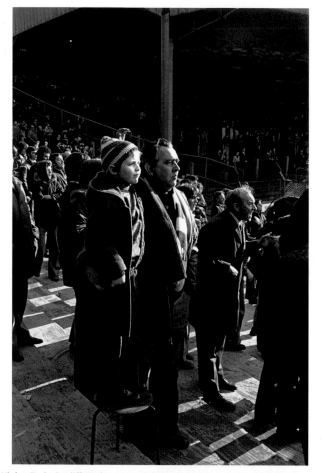

David Hurn, Ninian Park, Cardiff, Wales, 1977. A father and son watch Cardiff City lose 3-1 to Chelsea

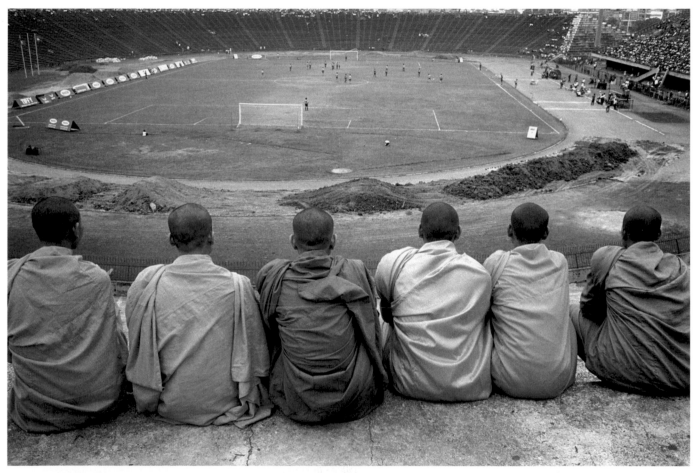

John Vink, Phnom Penh, Cambodia, 1999. Monks watching Kompong Cham beat Siem Reap 1-0 in the finals of the Cambodian Football League

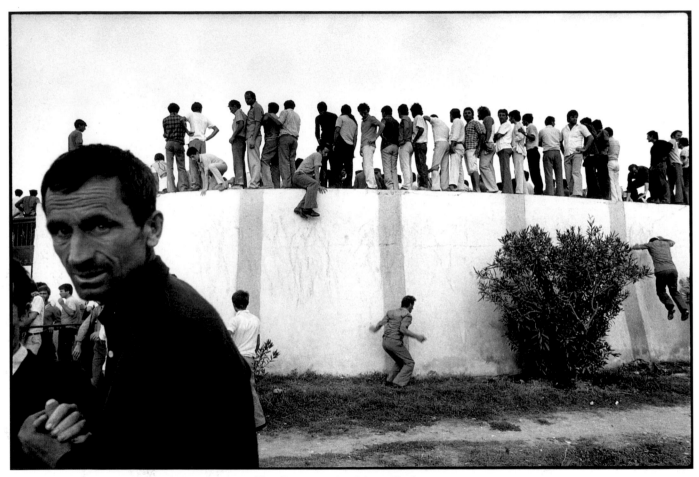

Nikos Economopoulos, Avlona, Albania, 1990

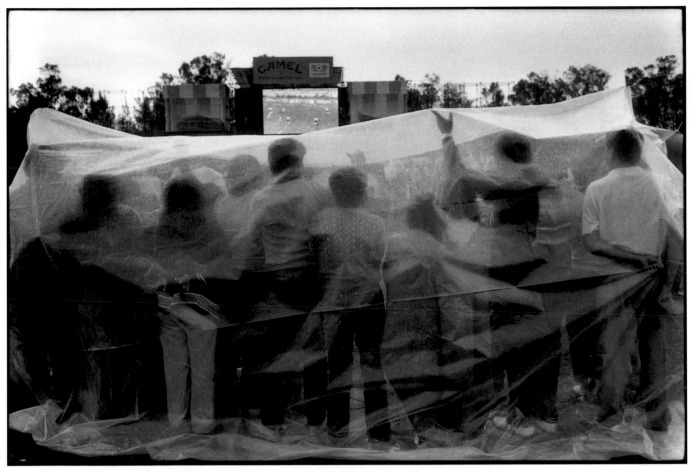

John Vink, Mexico City, Mexico, 1986. Crowds watch a World Cup match on a giant screen

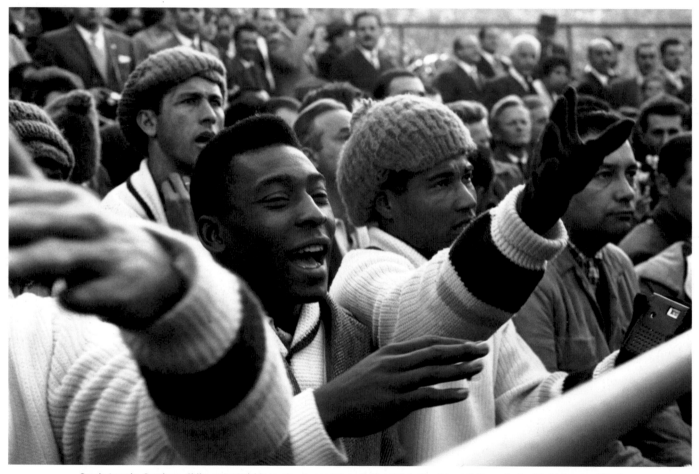

Sergio Larrain, Santiago, Chile, 1962. Unable to play due to injury, Pelé watches Brazil beat Chile 4-2 in the World Cup semi-final

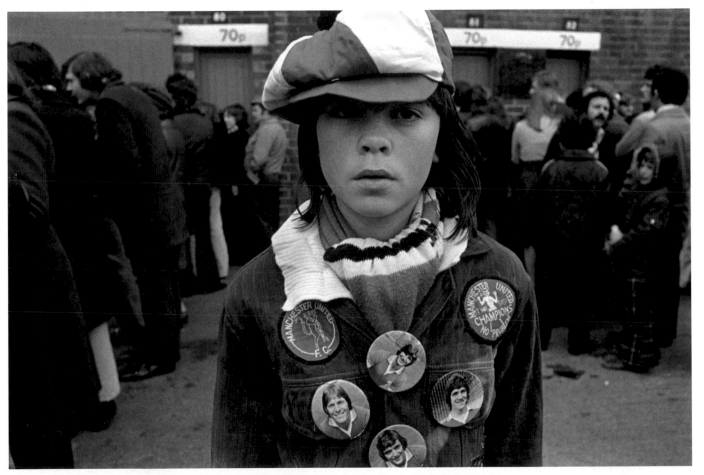

Peter Marlow, Manchester, England, 1977. Manchester United supporter

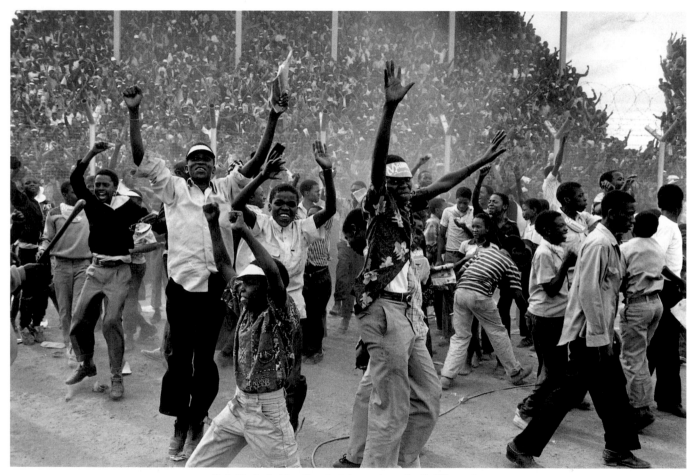

Chris Steele-Perkins, Soweto, Johannesburg, South Africa, 1982

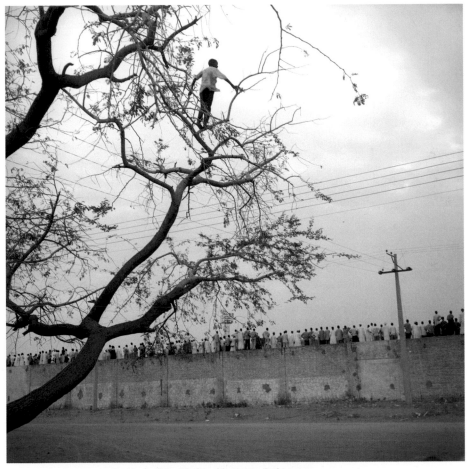

Peter Marlow, Khartoum, Sudan, 1997

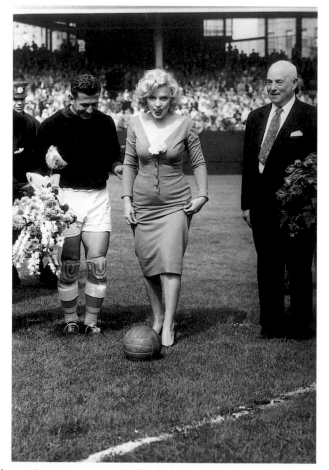

Bob Henriques, New York, USA, 1959. In town to promote her film *Some Like it Hot*, Marilyn Monroe kicks off a match at Yankee Stadium

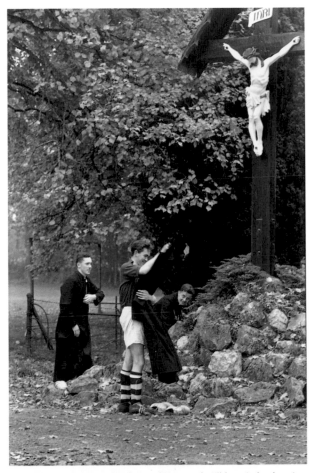

Henri Cartier-Bresson, Seminary of Maynooth, Kildare, Ireland, 1962

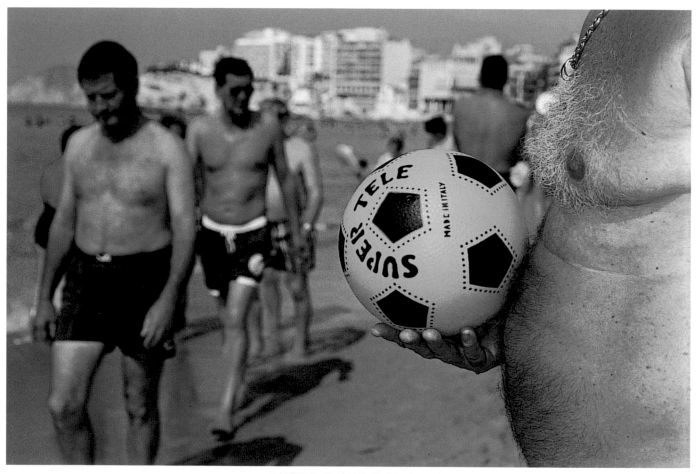

Martin Parr, Benidorm, Spain, 1997

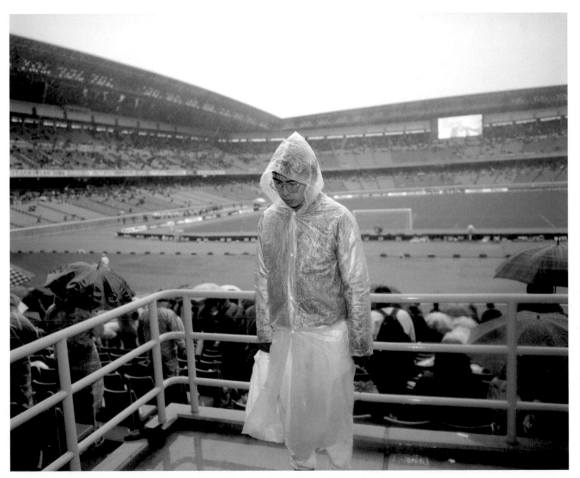

Martin Parr, Yokohama Stadium, Japan, 1998

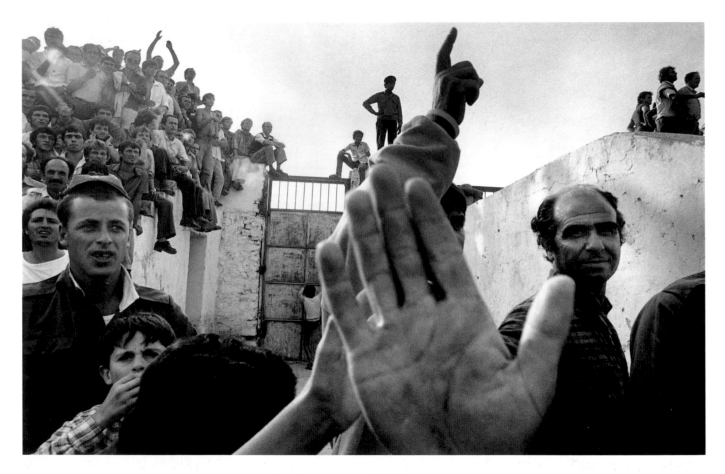

Nikos Economopoulos, Vlorë, Albania, 1990

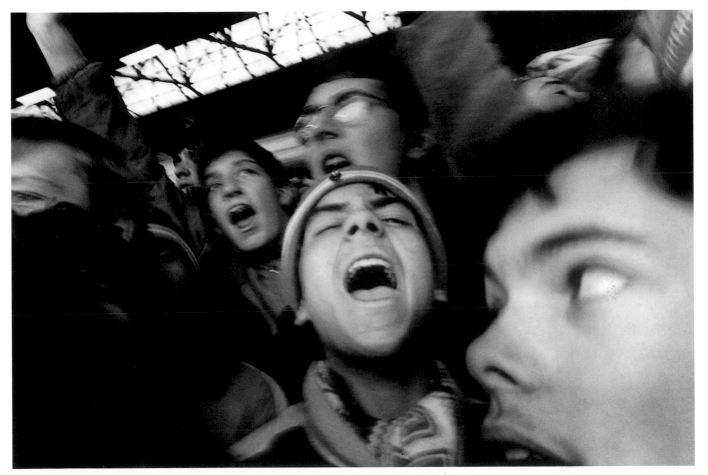

Peter Marlow, Anfield Stadium, Liverpool, England, 1986

Guy Le Querrec, Stade du 4 Août, Ouagadougou, Burkina Faso, 1998
Spectators at the African Nations Cup third place match between Burkina Faso and the People's Republic of Congo.
Congo won in a penalty shoot-out

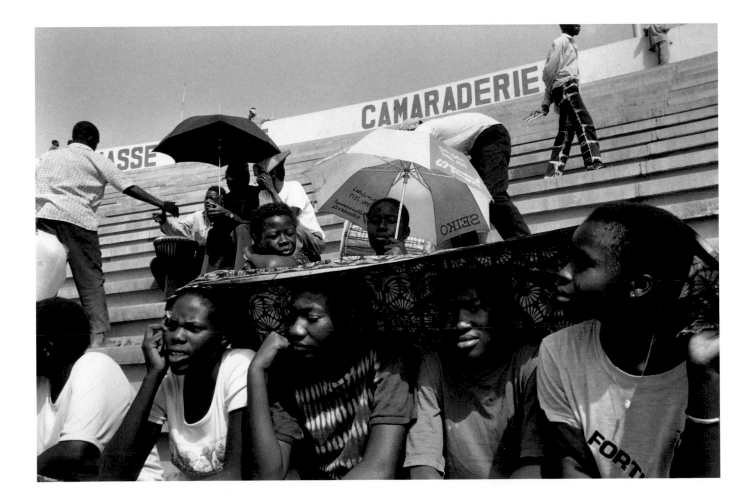

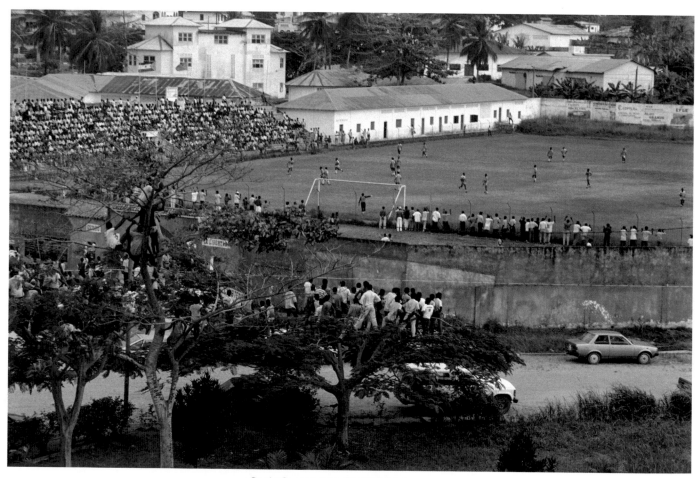

Guy Le Querrec, Bata, Equatorial Guinea, 1990

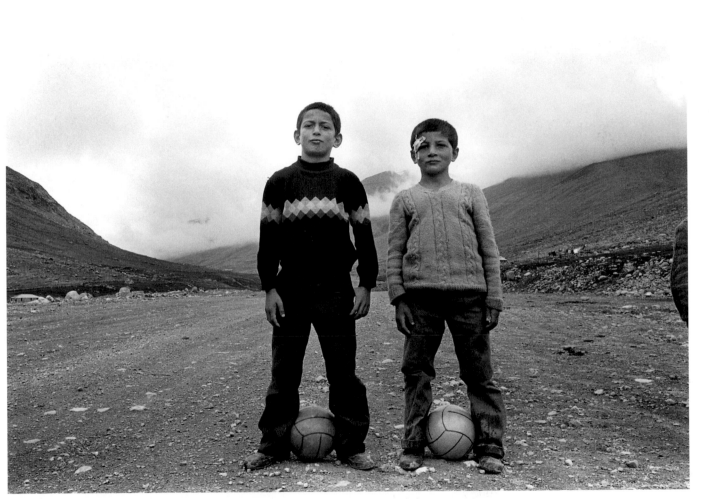

Nikos Economopoulos, near Erzurum, Turkey, 1991

THE PASS

'All that I know most surely about morality and the obligations of man, I owe to football'

Albert Camus (writer and goalkeeper for Algeria)

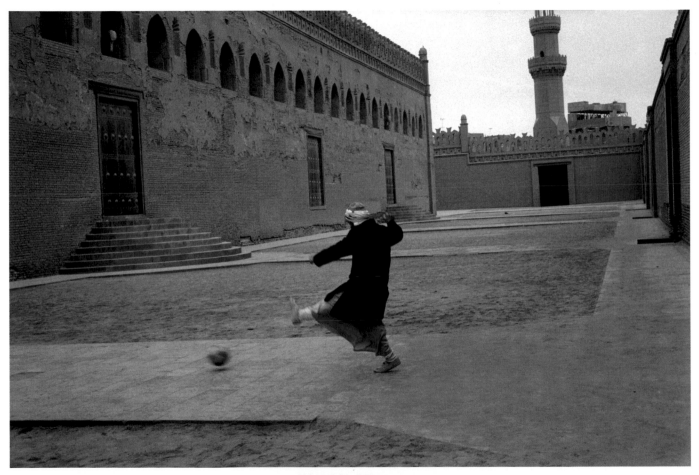

Abbas, Cairo, Egypt, 1993

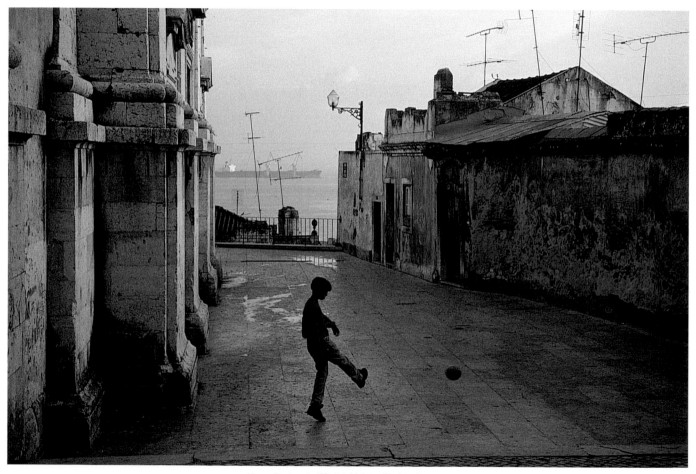

Harry Gruyaert, Alfama, Lisbon, Portugal, 1994

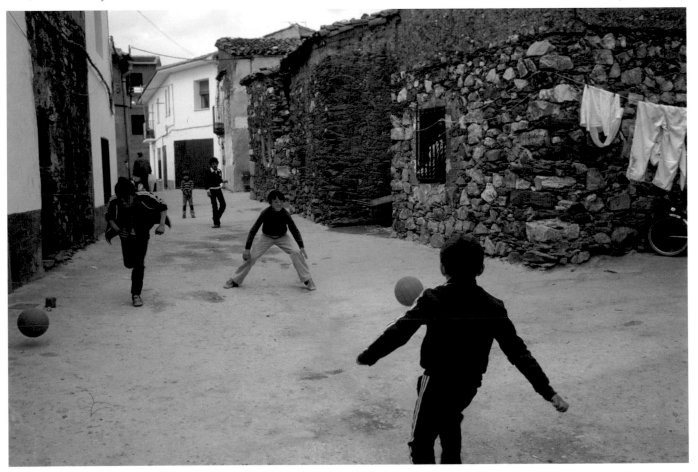

Jean Gaumy, Madrid, Spain, 1982

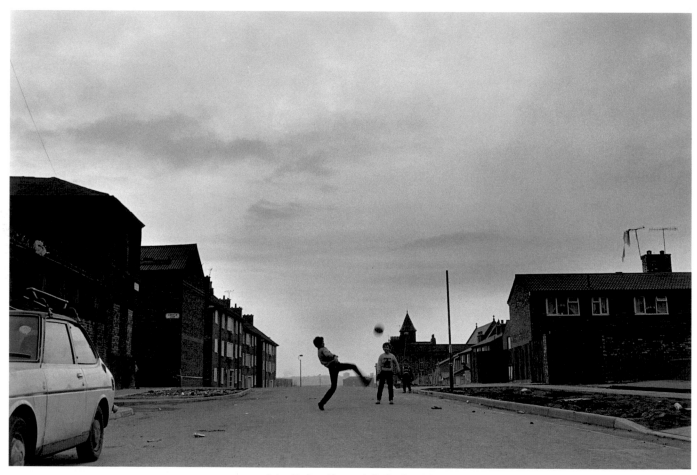

Peter Marlow, Liverpool, England, 1986

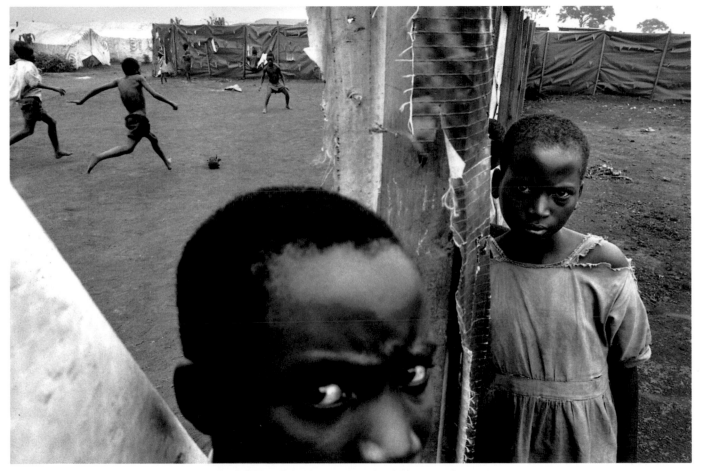

Eli Reed, Benaco, Tanzania, 1995. Rwandan children at a refugee camp

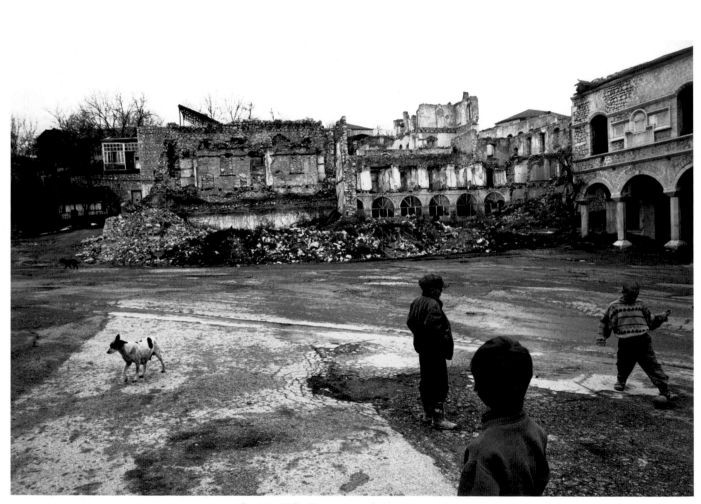

Donovan Wylie, Nagornyy-Karabakh, Armenia, 1996

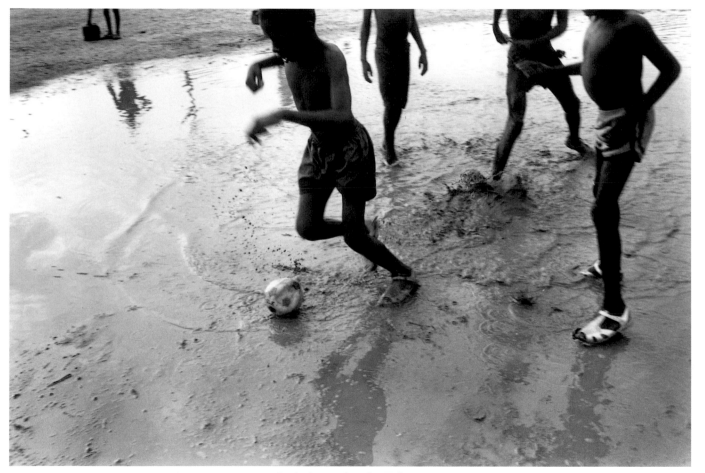

Guy Le Querrec, Bamako, Mali, 1984

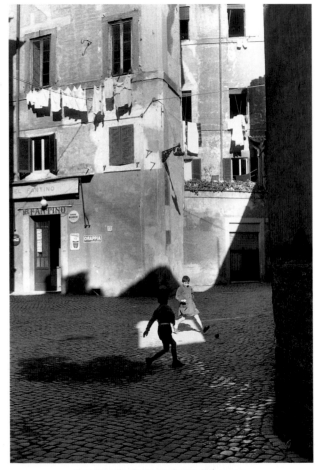

Henri Cartier-Bresson, Rome, Italy, 1959

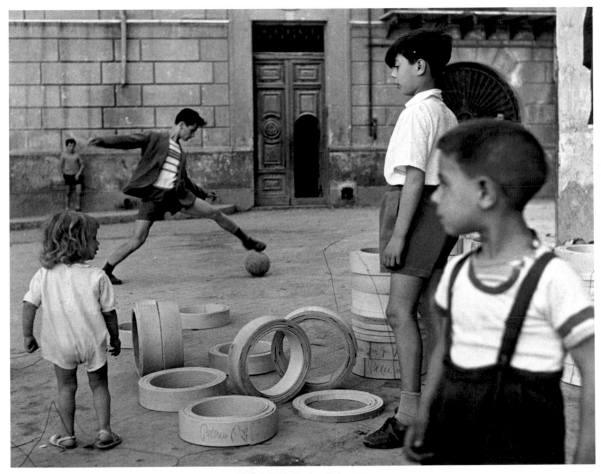

Herbert List, Naples, Italy, 1959

Alex Webb, Port-au-Prince, Haiti, 1987

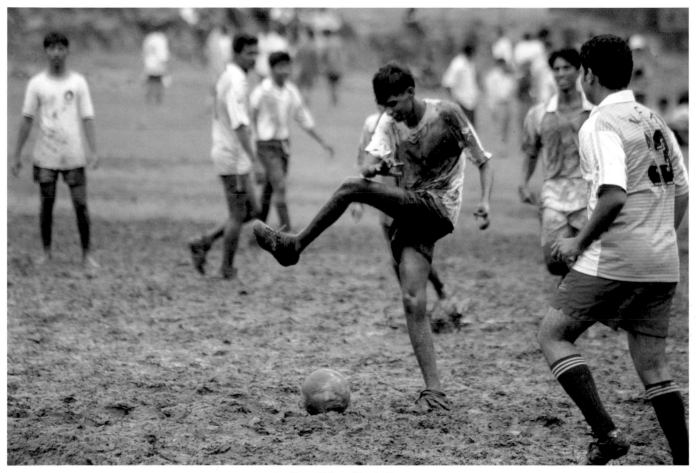

Ian Berry, Maharashtra, India, 1999

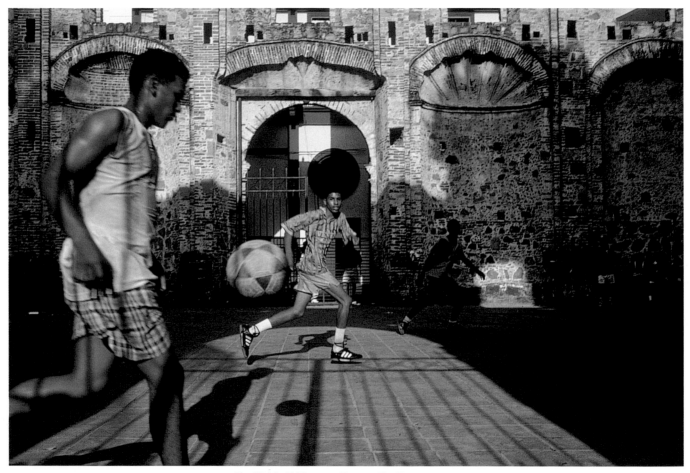

Alex Webb, Old Panama, Panama City, Panama, 1999

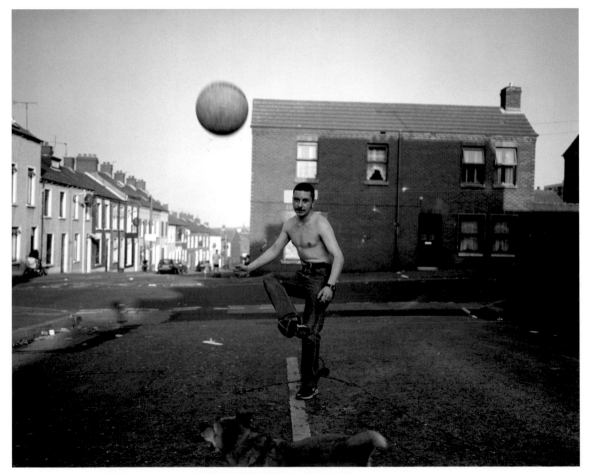

Donovan Wylie, Belfast, Northern Ireland, 1999

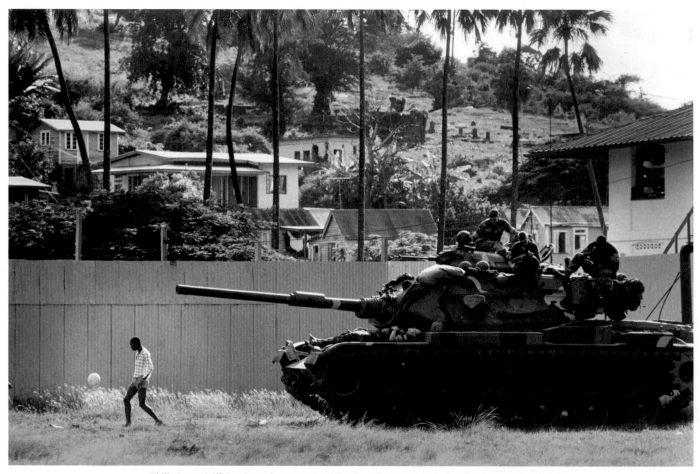

Philip Jones Griffiths, Grenada, 1983. Practising by an American tank shortly after the invasion

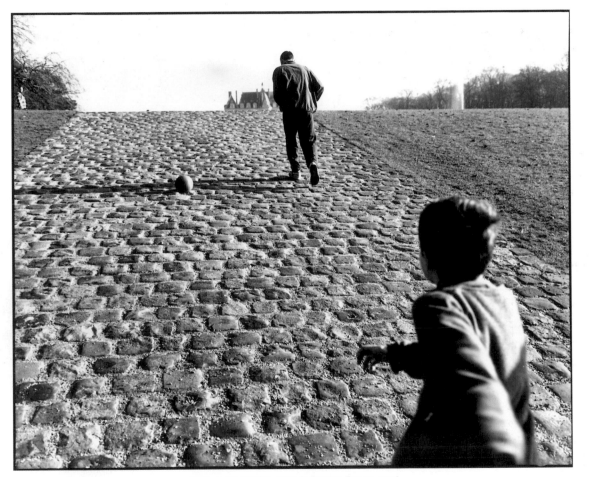

Raymond Depardon, Parc de Sceaux, France, 1996

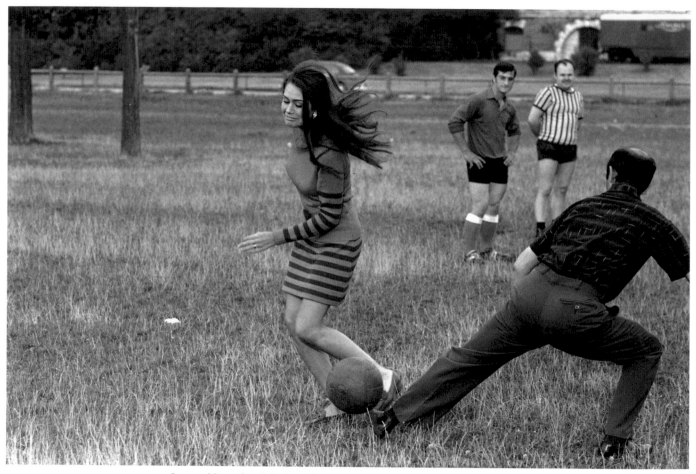

Raymond Depardon, Bois de Boulogne, Paris, France, 1967. Actress Corinne Piccoli

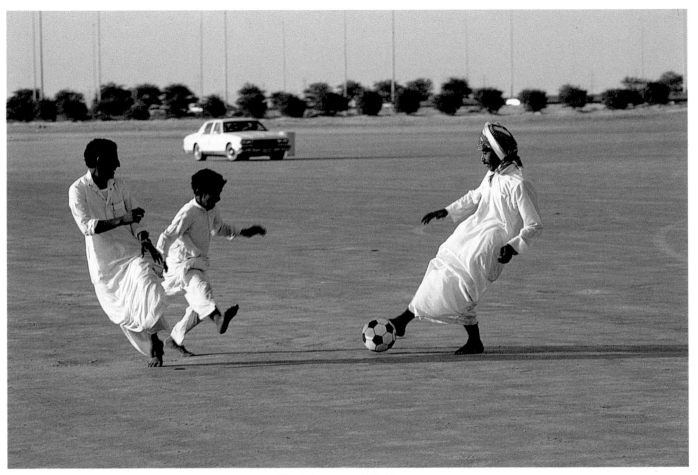

Abbas, Dhahran, Saudi Arabia, 1990

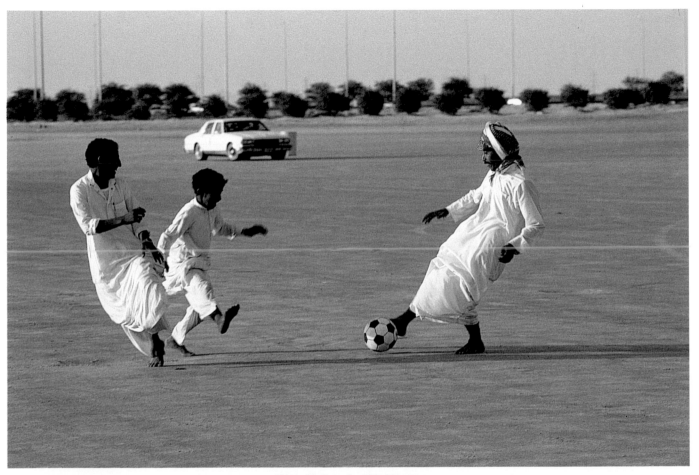

Abbas, Dhahran, Saudi Arabia, 1990

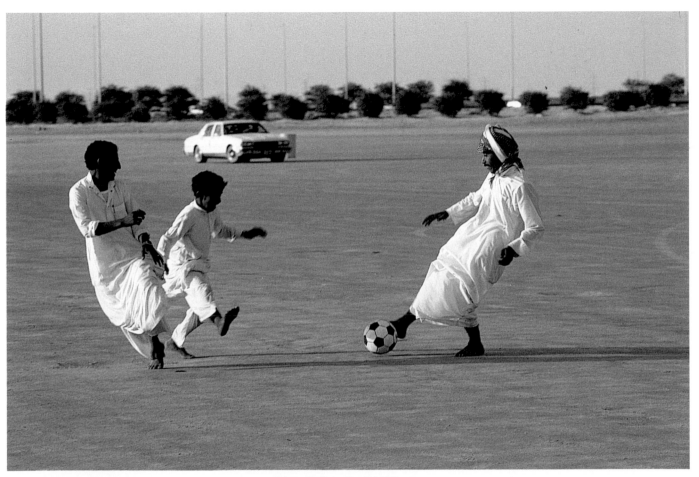

Abbas, Dhahran, Saudi Arabia, 1990

THE BEAUTIFUL GAME

'Football. It's the beautiful game'

Pelé

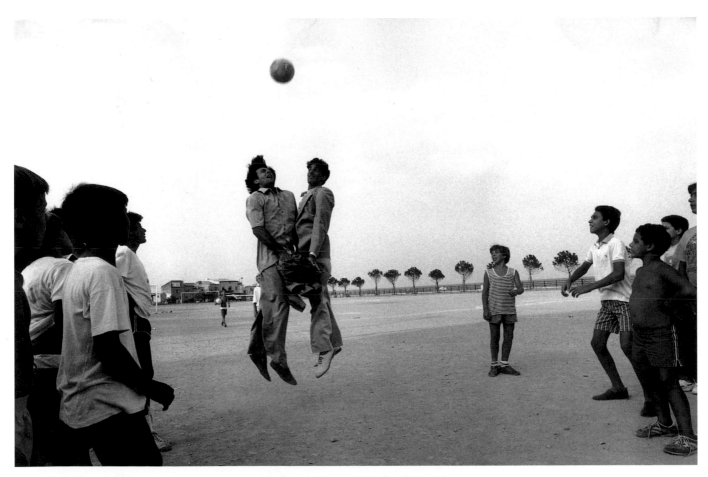

Ferdinando Scianna, Porticello, Sicily, 1988

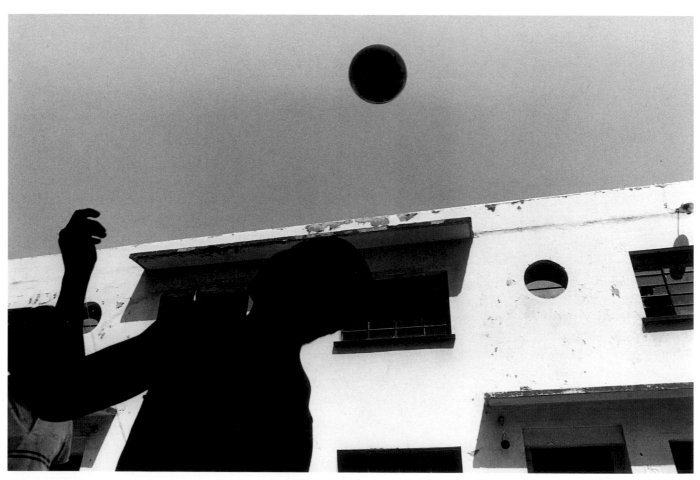
Kent Klich, Mexico City, Mexico, 1992

122

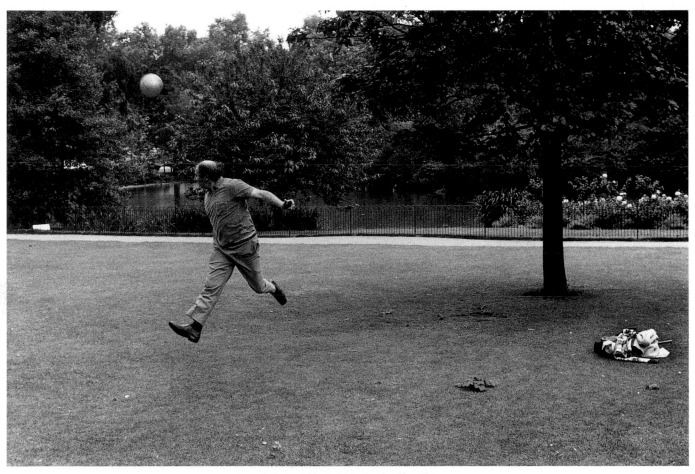

Ian Berry, Hyde Park, London, England, 1974

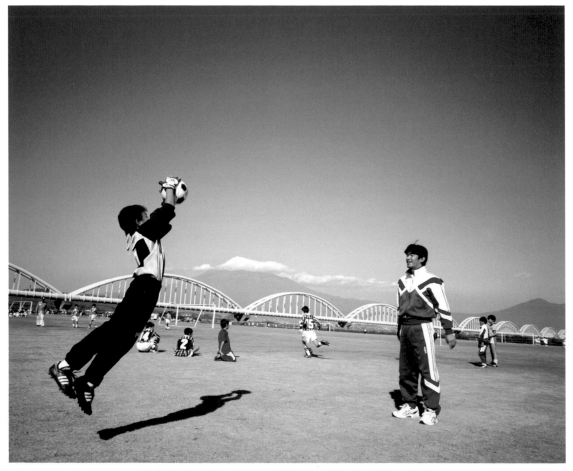

Chris Steele-Perkins, Japan, 1998. Training at the foot of Mount Fuji

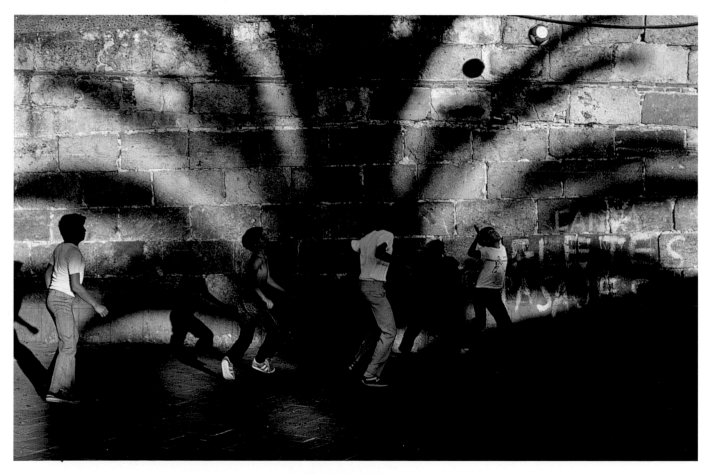

Alex Webb, Oaxaca, Mexico, 1982

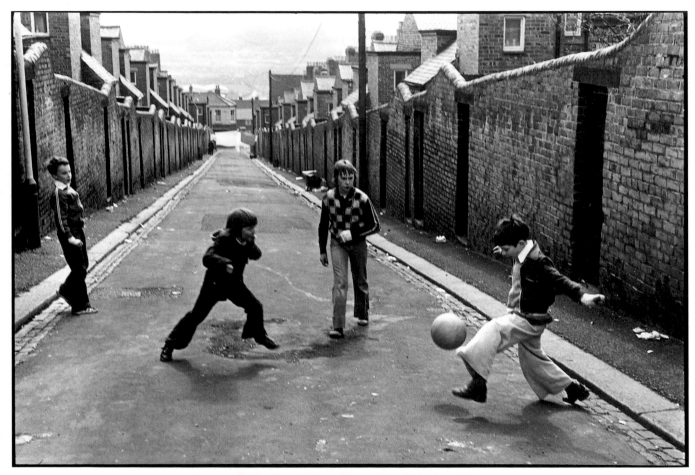

Martine Franck, Newcastle-upon-Tyne, England, 1977

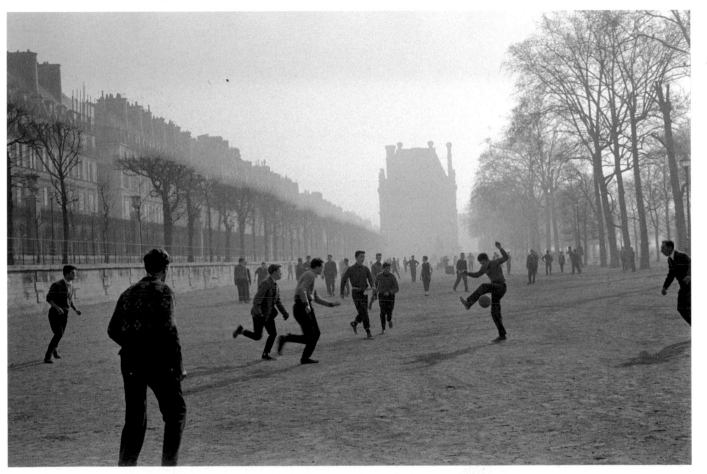

Sergio Larrain, Tuileries Gardens, Paris, France, 1959

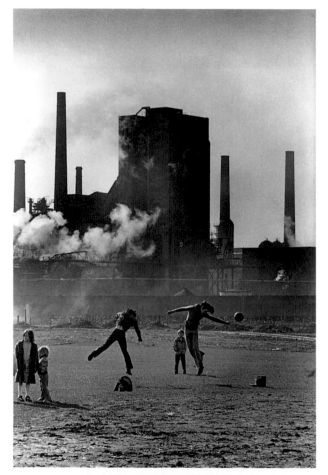

David Hurn, East Moors, Wales, 1978

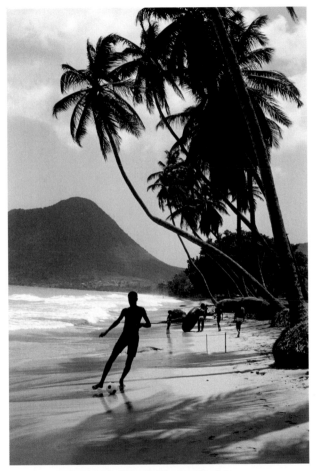

Martine Franck, Plage du Diamant, Martinique, 1973

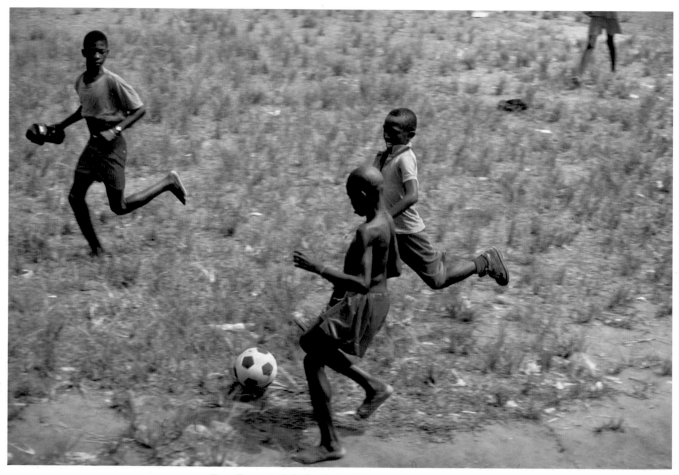

Harry Gruyaert, Catholic mission, Kometou, Cameroon, 1998

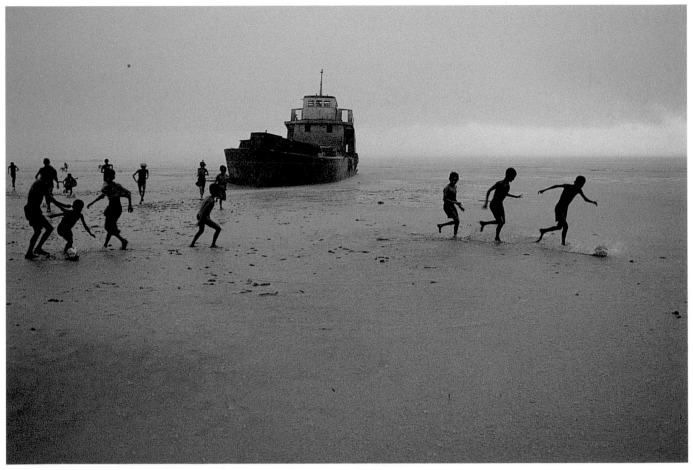

Steve McCurry, Sittwe, Burma, 1996

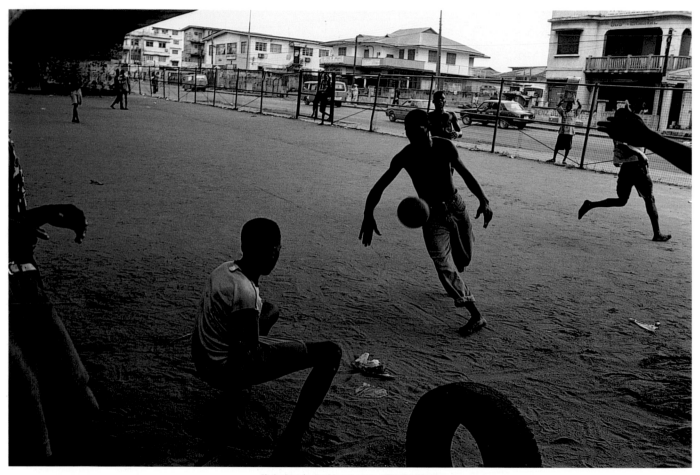

Chris Steele-Perkins, Lagos, Nigeria, 1997

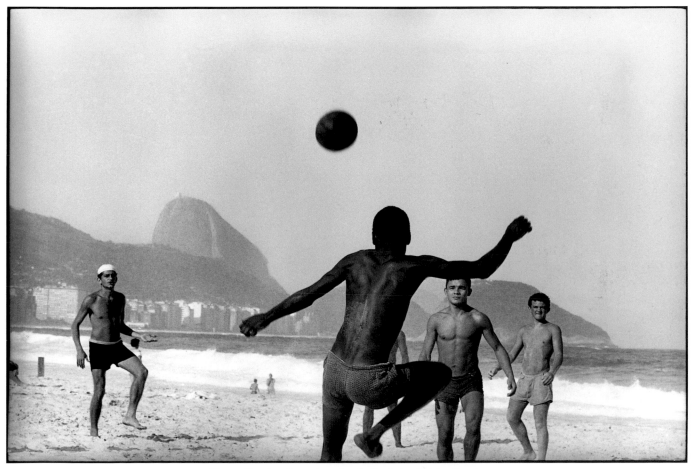

Thomas Hoepker, Copacabana Beach, Rio de Janeiro, Brazil, 1962

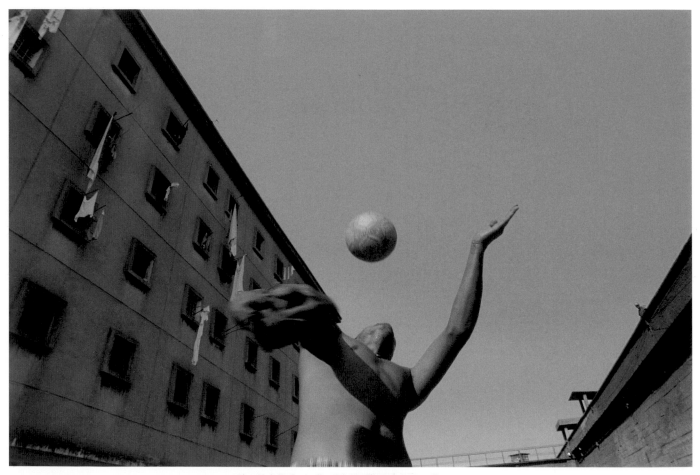

Alex Majoli, Carandiru Prison, São Paulo, Brazil, 1997

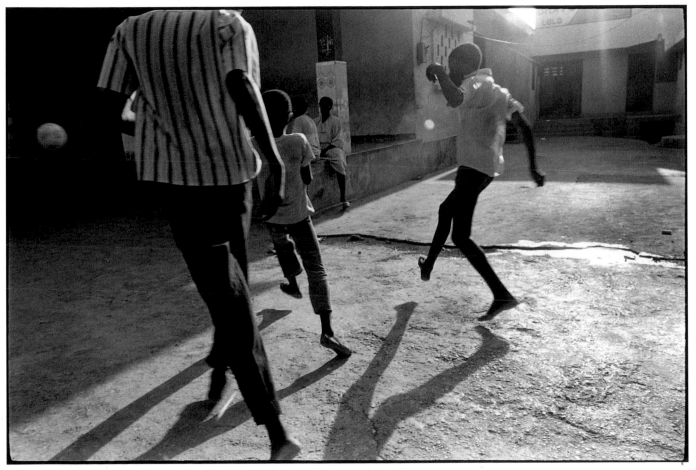

Bruce Gilden, Port-au-Prince, Haiti, 1990

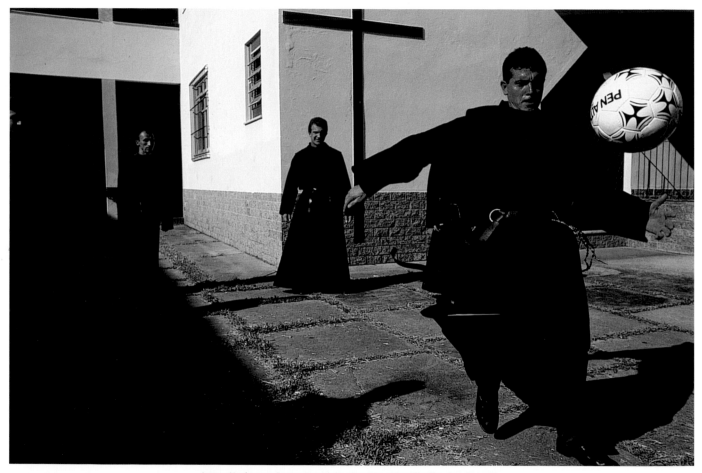

James Nachtwey, Santo Agostinho Seminary, Bom Jardim, Brazil, 1998

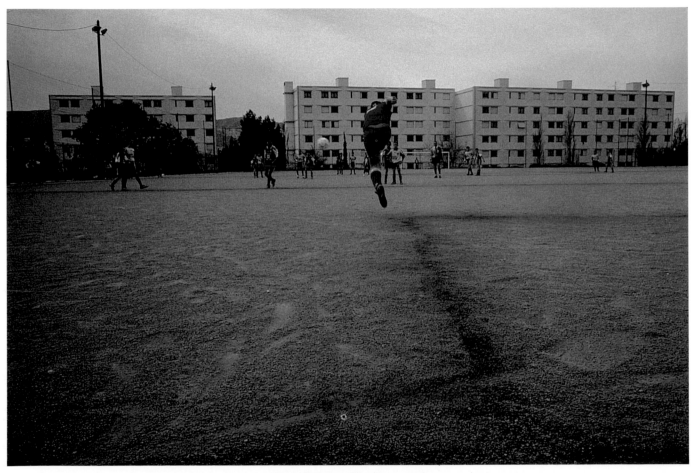

Lise Sarfati, Marseilles, France, 1998

THE GOAL

'Football ... is war minus the shooting'

George Orwell

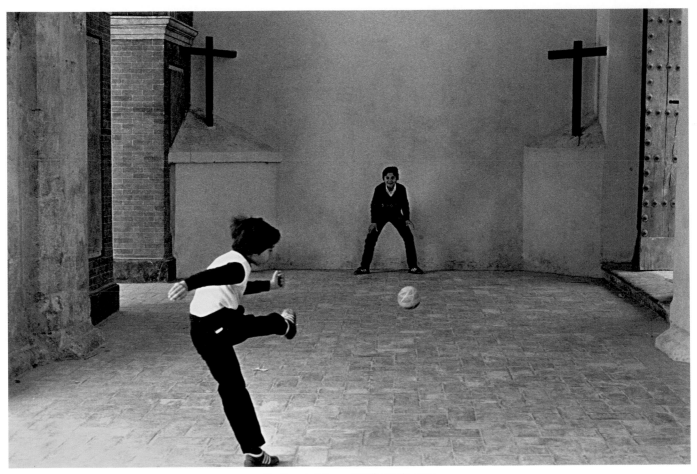

Ferdinando Scianna, Seville, Spain, 1984

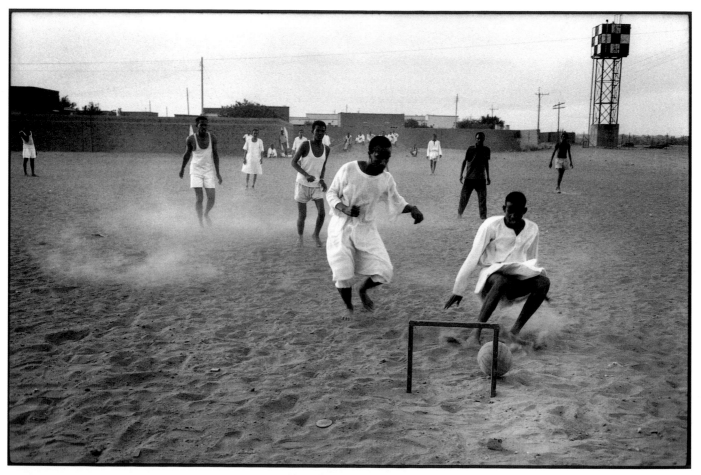

Abbas, Khartoum, Sudan, 1972

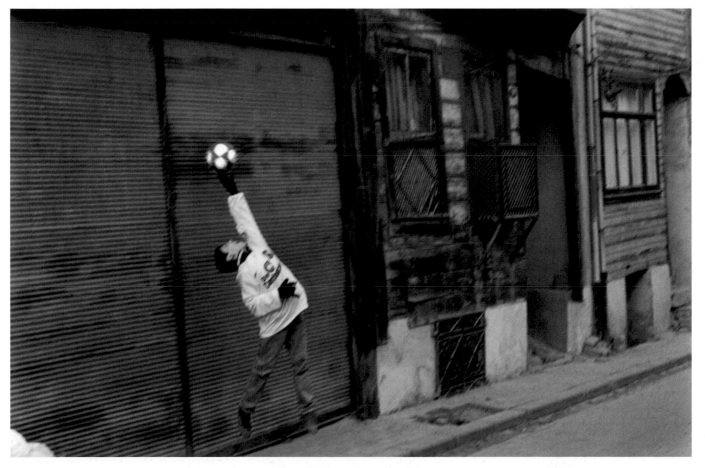

Marc Riboud, Istanbul, Turkey, 1986

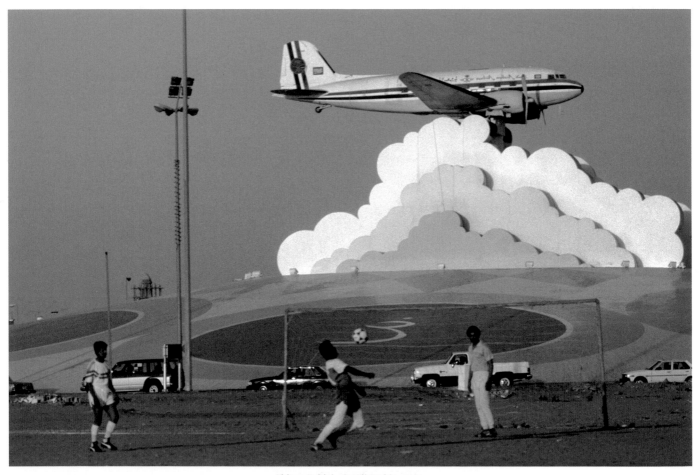

Abbas, Jeddah, Saudi Arabia, 1990

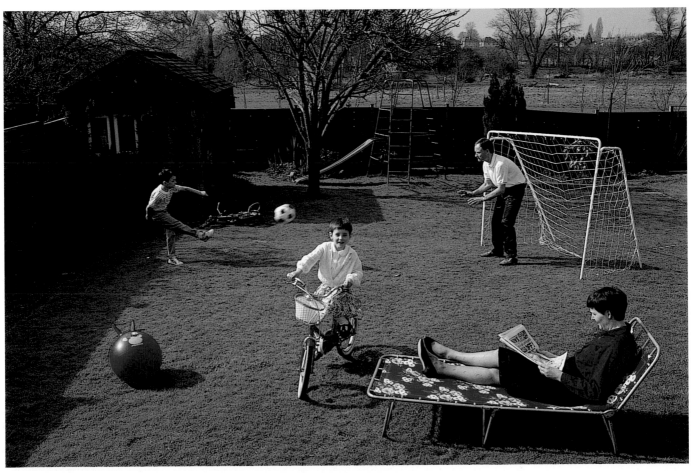

Chris Steele-Perkins, England, 1982

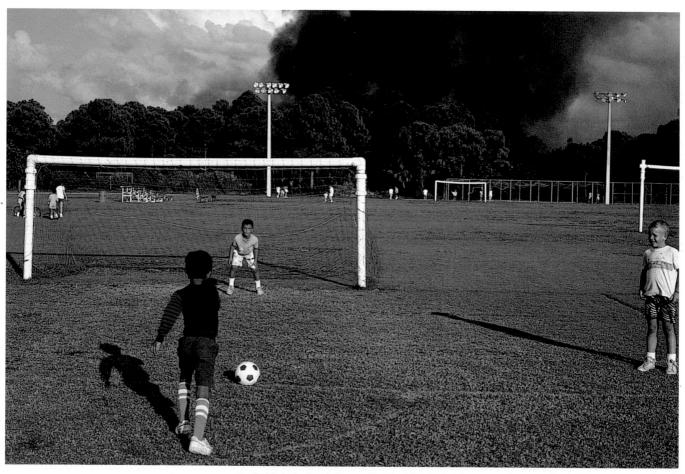

Alex Webb, Palm Beach County, Florida, USA, 1988

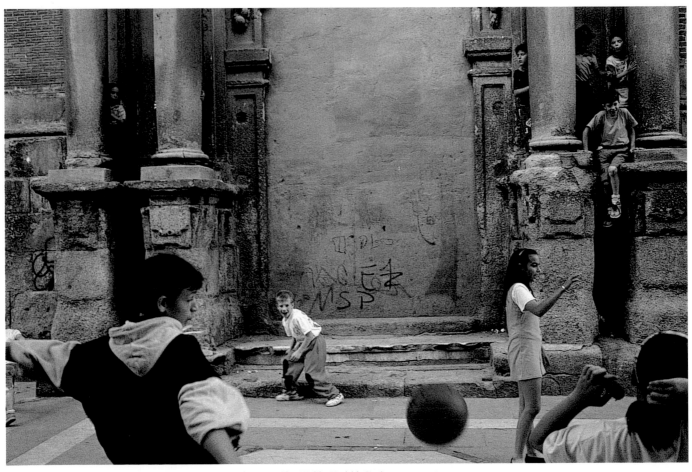

Alex Webb, Madrid, Spain, 1992

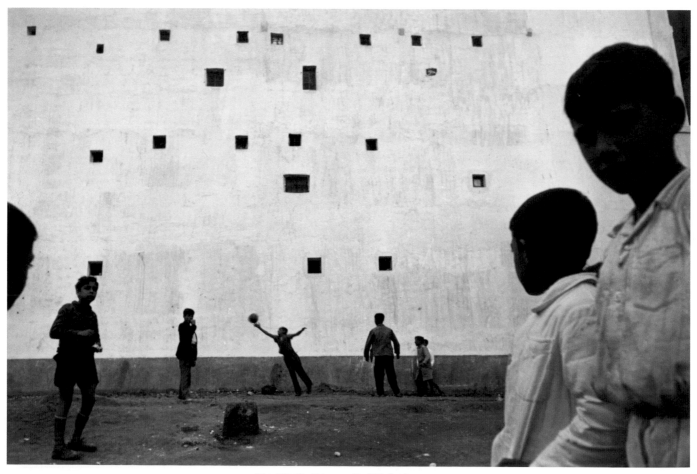

Henri Cartier-Bresson, Madrid, Spain, 1933

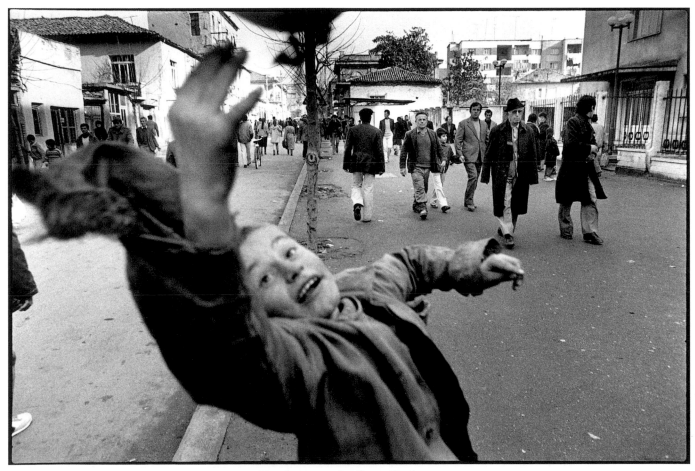

Nikos Economopoulos, Tirana, Albania, 1991

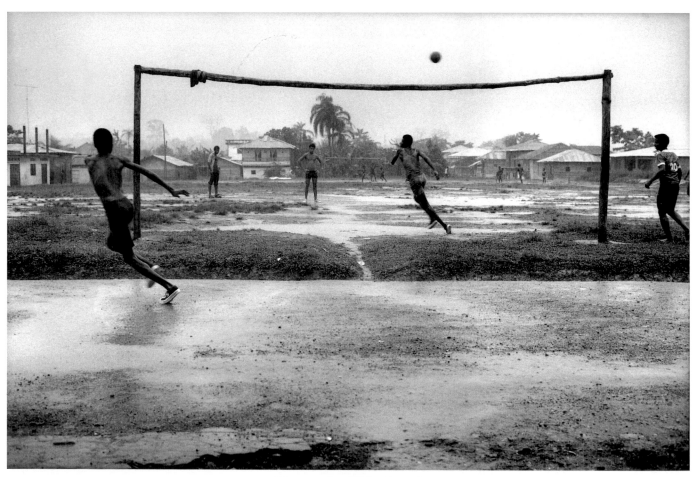

Abbas, near Guapi, Colombia, 1976

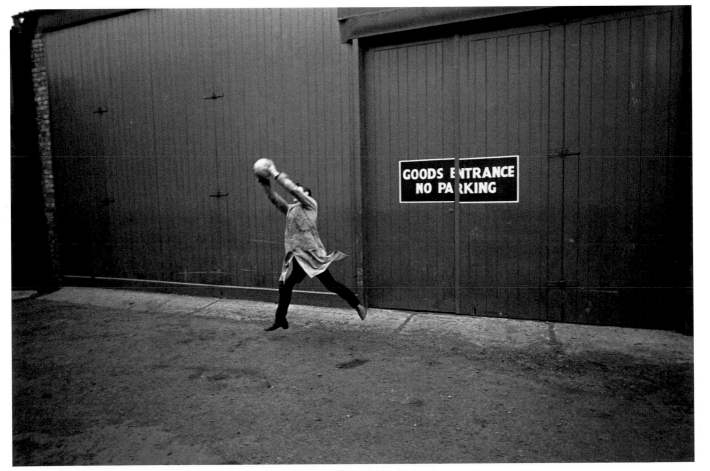

Bruno Barbey, Edinburgh, Scotland, 1965

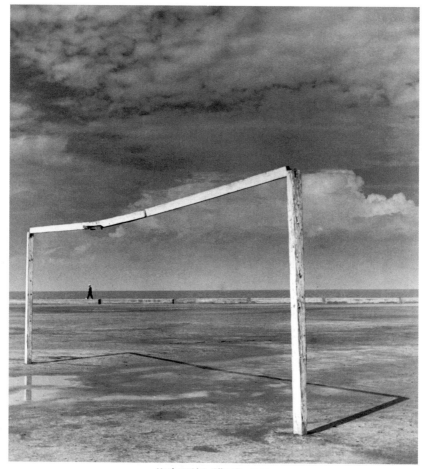

Herbert List, Albania, 1937

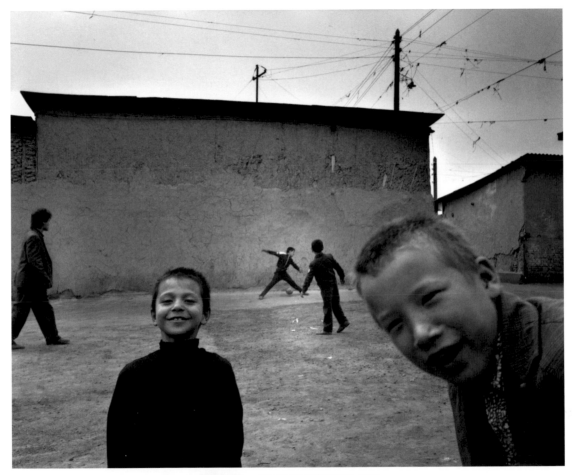

Carl de Keyzer, Tashkent, Uzbekistan, 1989

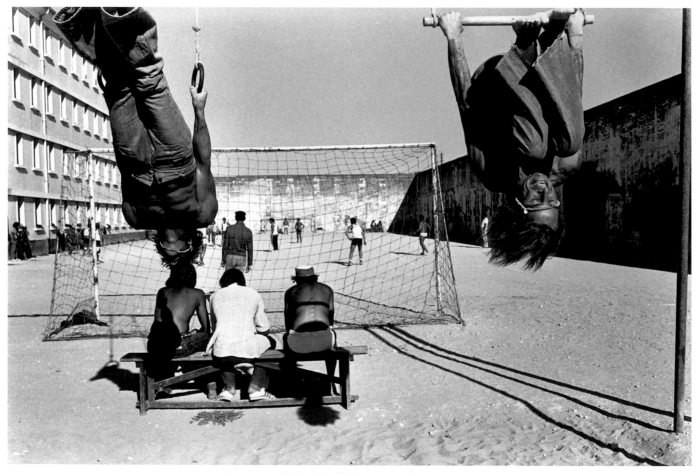

Jean Gaumy, St Martin de Ré, France, 1978. Prison inmates

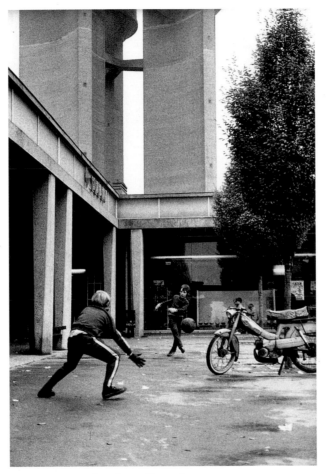

Jean Gaumy, Rouen, France, 1971

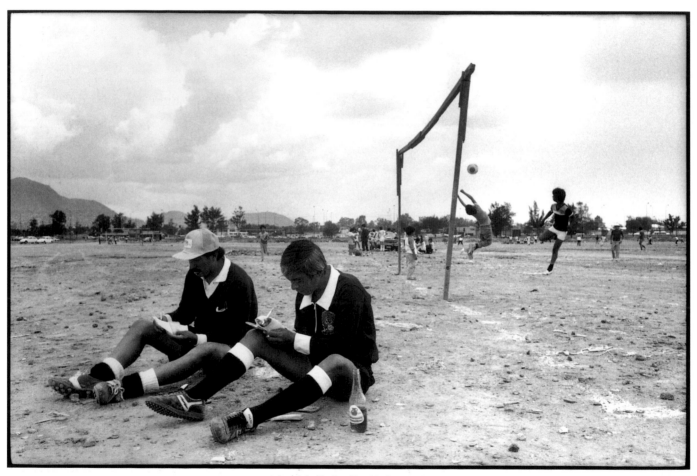

John Vink, Mexico City, Mexico, 1986

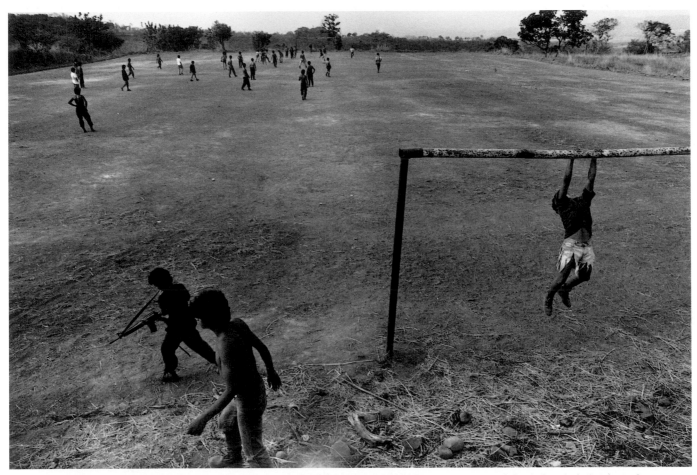

Larry Towell, Cuscatlán, El Salvador, 1982. Guerrillas playing after the signing of the January 1992 peace accords but before the laying down of arms

THE PASSION

'Some people believe football is a matter of life and death.
I'm very disappointed with that attitude.
I can assure you it is much, much more important than that'

Bill Shankly (former manager of Liverpool FC)

Peter Marlow, Liverpool, England, 1986
Liverpool fans celebrate as Ian Rush scores his second goal in the 1986 FA Cup final against local rivals Everton.
The match ended 3-1

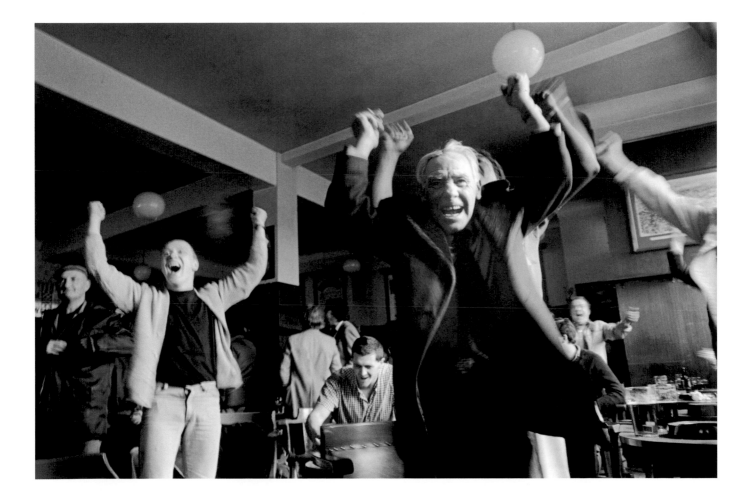

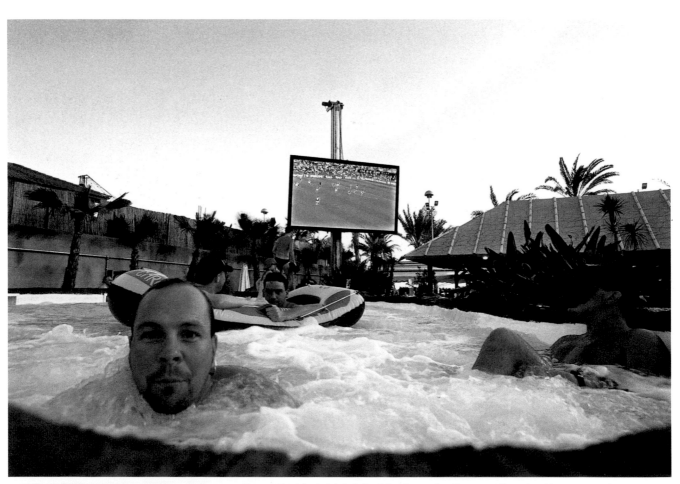

Ferdinando Scianna, Málaga, Spain, 2000. German tourists watch Italy beat Sweden 2-1 in a European Championship group match

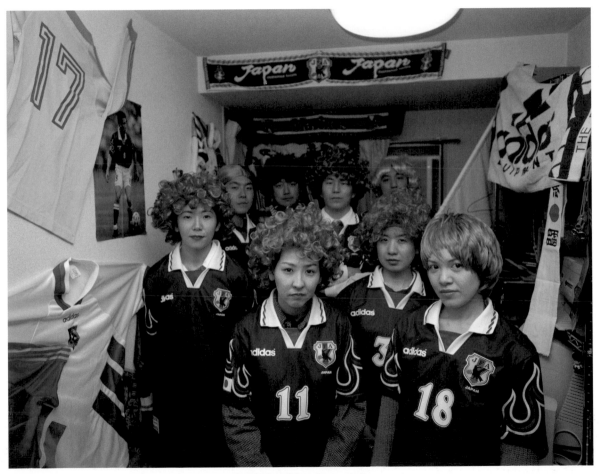

Martin Parr, Tokyo, Japan, 1998

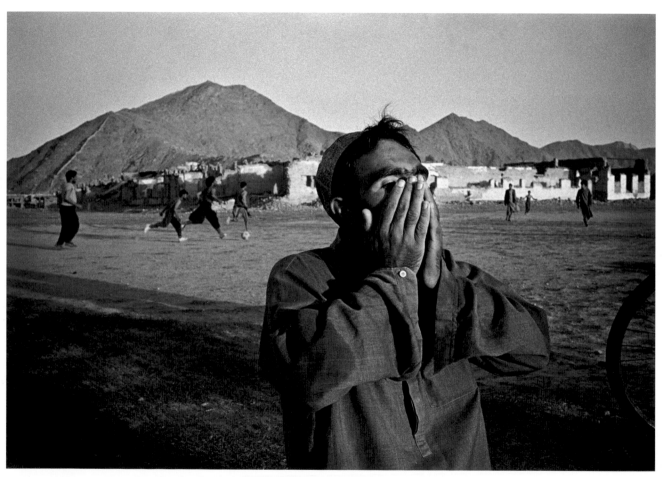

Joachim Ladefoged, Kabul, Afghanistan, 1996

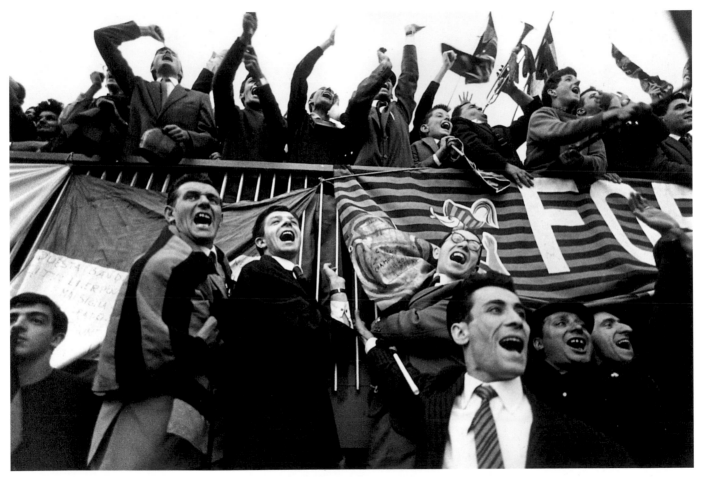

Bruno Barbey, Milan, Italy, 1966

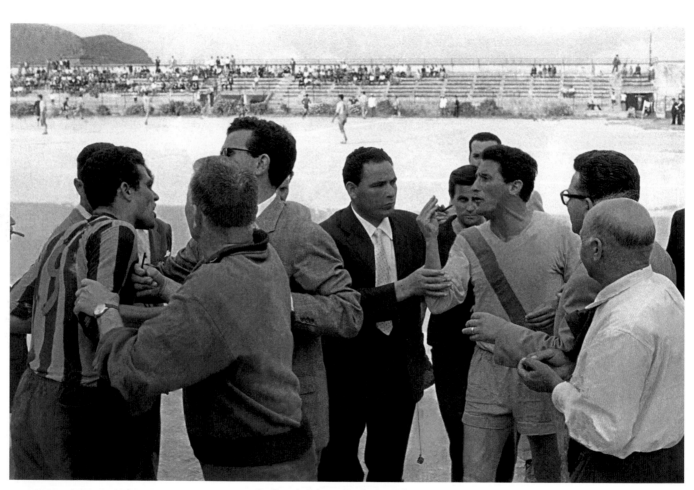

Ferdinando Scianna, Bagheria, Sicily, 1969

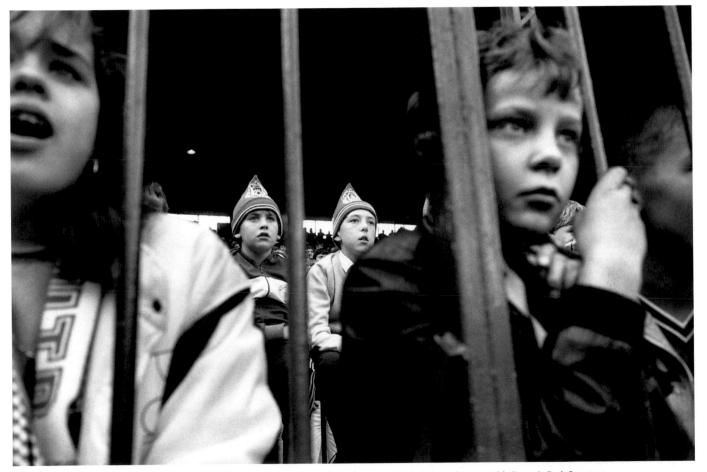

Stuart Franklin, London, England, 1983. Manchester United fans watch their team draw 1-1 with Queen's Park Rangers

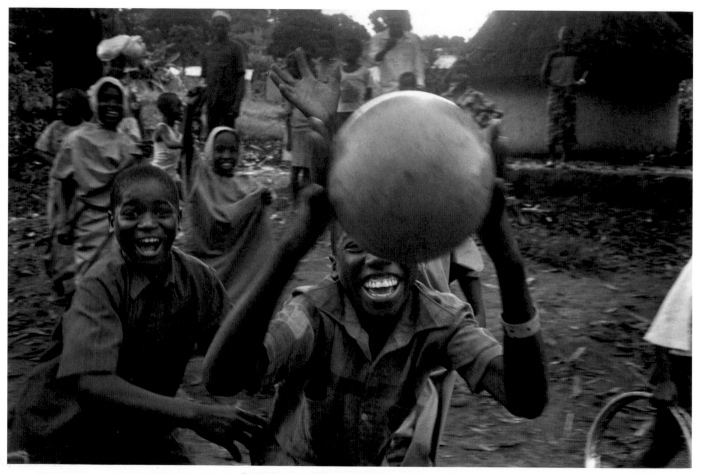

Guy Le Querrec, village near Mamou, Guinea, 1988

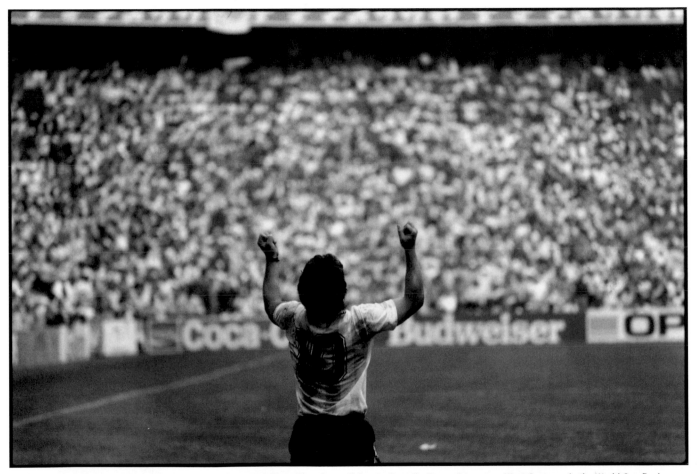

John Vink, Azteca Stadium, Mexico City, Mexico, 1986. Diego Maradona celebrates Argentina's 3-2 victory over West Germany in the World Cup final

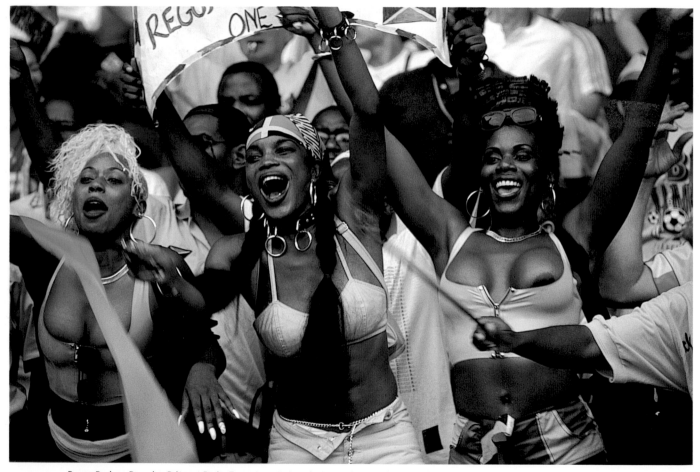

Bruno Barbey, Parc des Princes, Paris, France, 1998. Jamaica supporters at the Argentina v Jamaica World Cup match. Jamaica lost 5-0

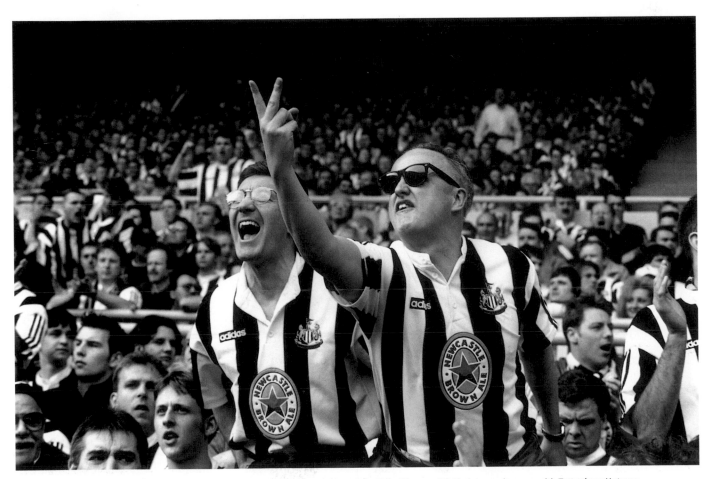

Chris Steele-Perkins, Newcastle-upon-Tyne, England, 1996. Newcastle United fans watch their team draw 1-1 with Tottenham Hotspur

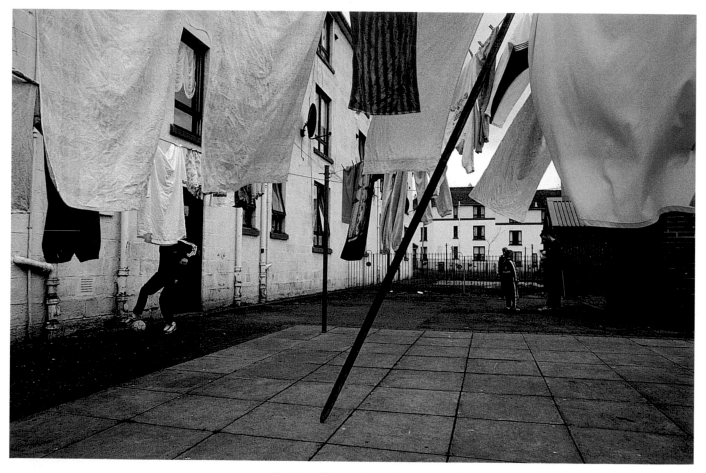

Paul Lowe, Glasgow, Scotland, 1998

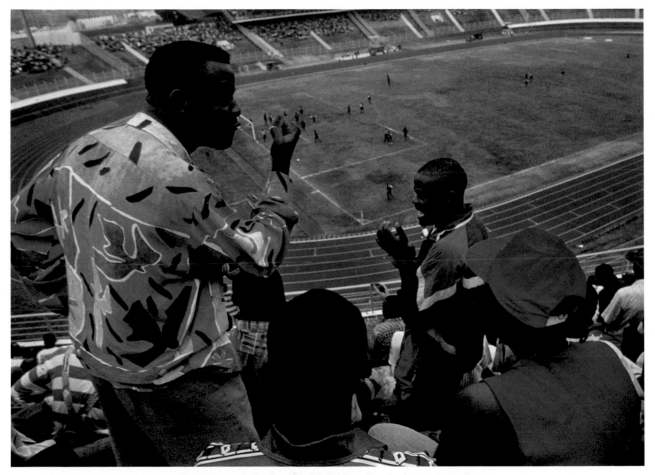

Harry Gruyaert, The Reunification Stadium, Douala, Cameroon, 1998

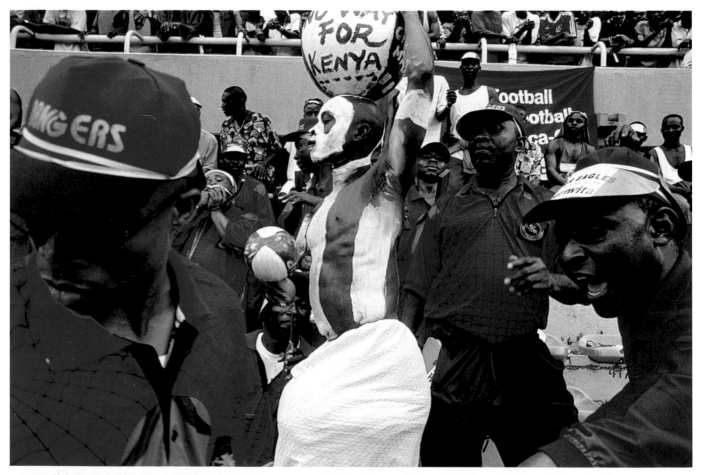

Chris Steele-Perkins, Lagos, Nigeria, 1997. Nigeria supporters at the World Cup qualifying match between Nigeria and Kenya. Nigeria won 3-0

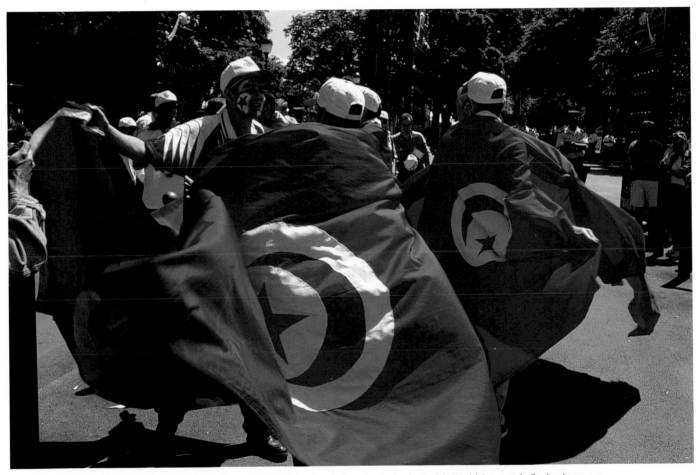

Bruno Barbey, Marseilles, France, 1998. Tunisian fans before the England v Tunisia World Cup match. England won 2-0

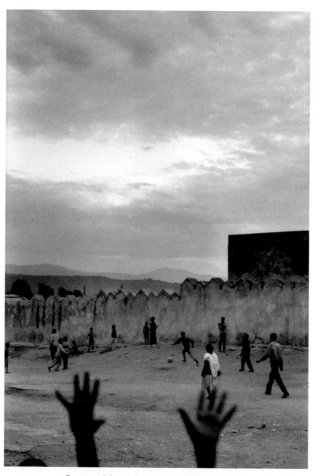

Raymond Depardon, Harar, Ethiopia, 1995

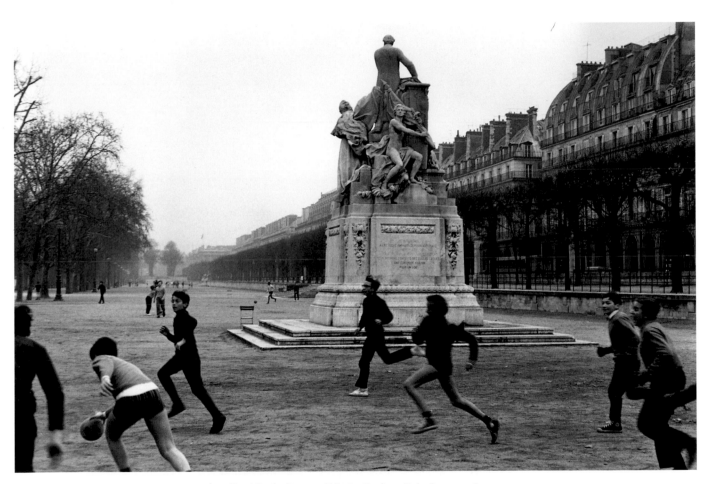

Henri Cartier-Bresson, Tuileries Gardens, Paris, France, 1969

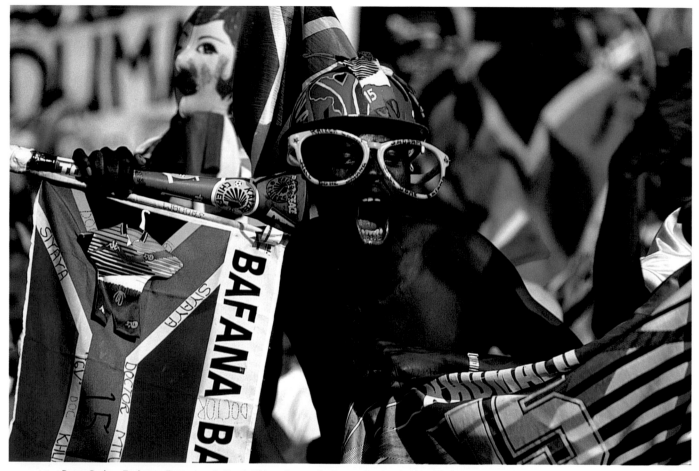

Bruno Barbey, Toulouse, France, 1998. South African fans at the Denmark v South Africa World Cup match. The game ended in a 1-1 draw

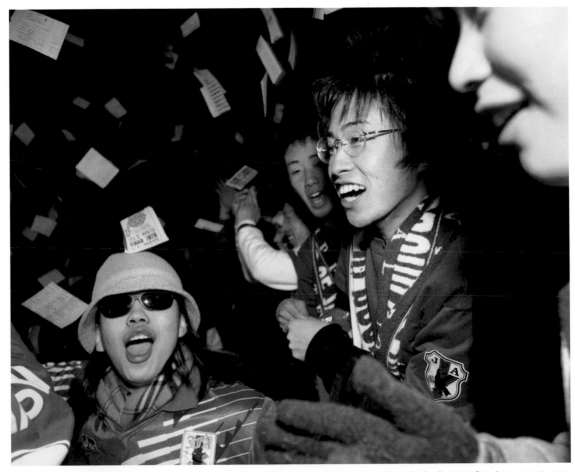

Martin Parr, National Stadium, Tokyo, Japan, 1998. Japanese fans celebrate a goal against Hong Kong in the Dynasty Cup. Japan went on to win 5-1

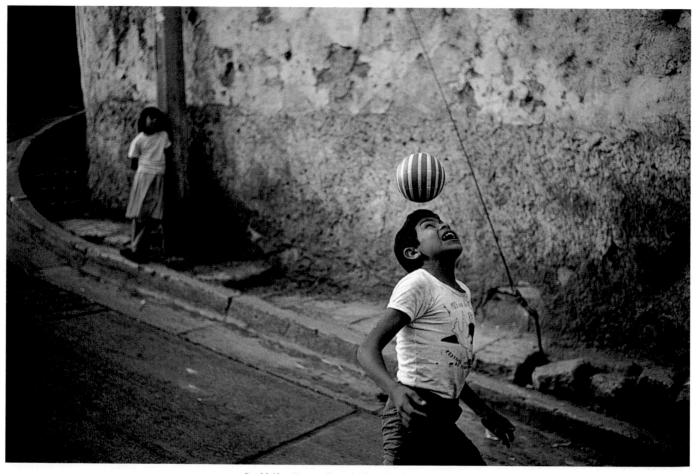

David Alan Harvey, Tegucigalpa, Honduras, 1990

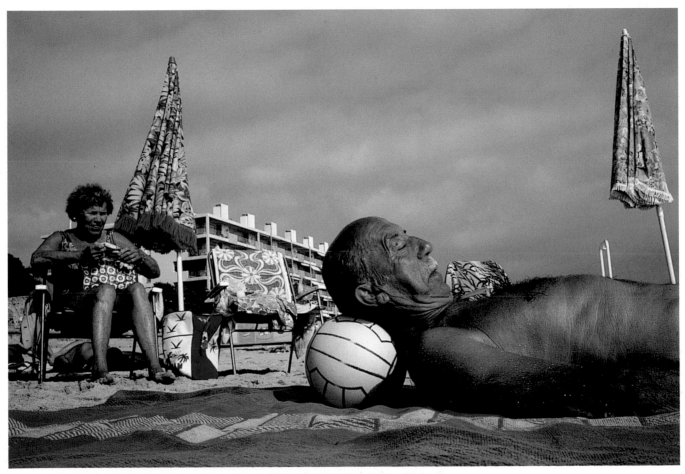

Peter Marlow, Antibes, France, 1992

Index of Photographers

Acknowledgements

The publishers would like to thank Liz Grogan and Hamish Crooks

for supplying the idea upon which this book is based.

Phaidon Press Limited

Regent's Wharf

All Saints Street

London N1 9PA

Phaidon Press Inc.

180 Varick Street

New York, NY 10014

www.phaidon.com

First published 2002

© 2002 Phaidon Press Limited

Photographs © Magnum Photos

ISBN 0 7148 4236 2

A CIP catalogue record for this book is available from the British Library.

Designed by Karl Shanahan

Printed in Hong Kong

ABBAS BRUNO BARBEY IAN BER
BRESSON LUC DELAHAYE RAYMO
NIKOS ECONOMOPOULOS MART
JEAN GAUMY BRUCE GILDEN BUR
HARRY GRUYAERT DAVID ALAN H
HOEPKER DAVID HURN RICHARD
KLICH JOSEF KOUDELKA JOACH
GUY LE QUERREC HERBERT LIST
MAJOLI PETER MARLOW SUSAN
NACHTWEY MARTIN PARR GUEOR
RIBOUD LISE SARFATI FERDINA
MARILYN SILVERSTONE CHRIS
JOHN VINK ALEX WEBB DONOV